IMAGES
of America

HAILEY

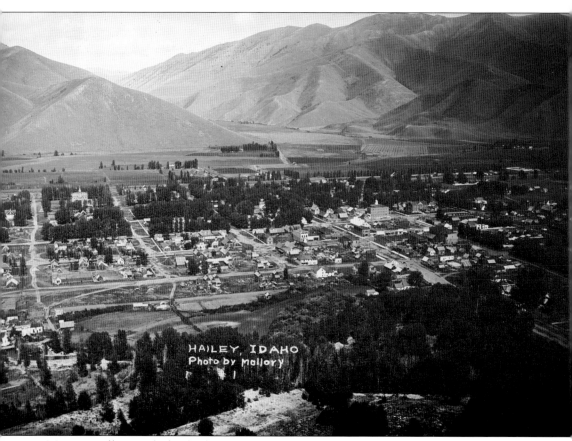

HAILEY, IDAHO
Photo by Mallory
#1

Martyn Mallory took this bird's-eye view of Hailey from Carbonate Mountain prior to 1920. Quigley Canyon is visible in the background. The population of Hailey was around 1,500 during this time. (Courtesy of the Mallory Photographic Collection, Hailey Public Library.)

IMAGES
of America

HAILEY

Robert A. Lonning, PhD

ARCADIA
PUBLISHING

Copyright © 2012 by Robert A. Lonning, PhD
ISBN 978-0-7385-8899-5

Published by Arcadia Publishing
Charleston, South Carolina

Printed in the United States of America

Library of Congress Control Number: 2011931590

For all general information, please contact Arcadia Publishing:
Telephone 843-853-2070
Fax 843-853-0044
E-mail sales@arcadiapublishing.com
For customer service and orders:
Toll-Free 1-888-313-2665

Visit us on the Internet at www.arcadiapublishing.com

This book is dedicated to the people of Hailey, past and present. Your
commitment to this community and each other is a source of inspiration.

CONTENTS

ACKNOWLEDGMENTS

I wish to thank the Hailey Public Library Board for granting me permission to use the photographs from the Mallory Collection, which supplied most of the images in this book. I also wish to thank Teddie Daley, director of the Blaine County Historical Museum, for her help in selecting and scanning images from the museum's wonderful collection made available to me through the kind permission of Bob McLeod and the museum board. Several other people provided invaluable assistance in making this book possible. John and Joan Davies and Ralph Harris provided support and wonderful photographs. I made extensive use of Madeline Buckendorf's research of early life in Hailey. Sandy Hofferber, of the Regional History Department of the Community Library in Ketchum, gave useful advice and help in locating oral histories and microfilm copies of early newspapers that are part of their collection. Peg Schroll, of the Idaho State Archives in Boise, provided assistance in locating several early photographs. Kim Johnson was instrumental in helping locate early businesses in Hailey. Lastly, I wish to thank Elizabeth and Caitlin for their support and counsel in preparing the manuscript. Unless otherwise noted, all images appear courtesy of the Mallory Photographic Collection, Hailey Public Library.

INTRODUCTION

The story of Hailey, Idaho, is a story of resilience and perseverance. From its earliest days, the residents of Hailey have faced obstacles and adversity and worked together to overcome them. At the same time, Hailey people have displayed the ability to strike a sensible balance between work and play.

Born as a mining boomtown in the early 1880s, Hailey's early fortunes were tied to the fluctuations in the market for silver and lead and the seasonal patterns of the weather. The region was far removed from the main routes of travel, and the long snowy winters were a major obstacle before the arrival of the railroad. Winter snow regularly blocked access to the Wood River Valley leading to long periods of isolation. The *Idaho Tri-Weekly Statesman* on December 28, 1880, wrote the following:

> The miner, the merchant and the lover, each and all, are in the same category—hemmed in, housed up, holed up like a bear. . . . Snow-shoeing [skiing] by day and dancing by night constitute the principal amusements of our citizens, and are indulged in by almost every one, without regard for age or sex.

News of the coming of the railroad to Hailey promised to forever remove the sense of isolation. The *Wood River Times* reported on February 7, 1883:

> As the days wear away slowly in the Valley, the trains will undoubtedly bring immense immigration and uninterrupted transportation the year 'round in the future. This winter will be the last that will be passed by residents in an isolated condition.

In the period when stagecoach travel was the fastest option, it took three and a half days to make the 150-mile trip from Hailey to Boise. With the completion of the railway in May 1883, the 300-mile trip from Salt Lake City to Hailey took only 12 hours.

During the first three years following the arrival of the railroad, Wood River Mines produced $2 million of silver and lead per year. At its peak, silver was selling for $1.50 an ounce. In 1893, the price of silver had sunk to less than 60¢ an ounce. By this time, most of the mines in the Wood River Valley were forced to close. The closing of the mines created a ripple effect that caused serious economic hardship for the local businesses.

During this same period, the Hailey community experienced two devastating fires. The first on September 24, 1883, destroyed all the buildings on the east side of Main Street from Croy to Bullion Streets. The loss from that fire was estimated to be $75,000 (over $1.5 million in today's dollars). The second fire on July 2, 1889, destroyed the four main business blocks from Croy to Carbonate Streets on both sides of Main Street. Following both fires, the community pulled together and rebuilt the business district. The *Wood River Times* on July 31, 1889, reported:

> The condition of business there is not such as to make it an easy matter for the people of Hailey to stand such losses, although some of the parties who lost in the fire, are, with the pluck and energy which has always characterized them, preparing to rebuild, and it won't be long before the business will be going on as though nothing had happened.

According to the Trailing of the Sheep website, by the late 1800s, sheepherding began to replace mining as the foremost industry in Idaho. In the southwest region, it is said that John Hailey brought the first sheep into the Wood River Valley in the late 1860s. At that time, Idaho recorded a breeding sheep population of 14,000. As the mines began to play out in the valley, the sheep industry filled an increasingly large role in the local economy. By 1890, there were a reported 614,000 sheep in Idaho. A 1905 newspaper stated that 95,000 sheep were sheared in a single week at a plant in nearby Picabo. In 1918, the sheep population reached 2.65 million, almost six times the state's human population.

On February 5, 1998, the *Economist* magazine stated that the sheep industry declined after World War II. "Weary of wool and tallowy mutton rations, ex-soldiers and their families shunned lamb chops and embraced synthetic fiber. The industry never recovered. Each decade brought more problems: subsidized producers in Australia and New Zealand, lack of cheap labor, increasing restrictions on grazing on public land, bans on poisoning predators, dwindling price supports, and finally, arguments among sheep ranchers themselves, who were probably the most cantankerous commodity producers in the country."

About the time that the sheep industry was beginning its decline in the Wood River Valley, the chairman of the Union Pacific Railroad, Averell Harriman, was looking for the perfect spot for a grand American resort. The success of the 1932 Winter Olympics in Lake Placid, New York, spurred an increase in participation in winter sports (and alpine skiing in particular). A lifelong skier, Harriman determined that Americans would embrace a destination mountain resort similar to those he enjoyed in the Swiss Alps. During the winter of 1935–1936, Harriman enlisted the services of Felix Schaffgotsch, an Austrian count, to travel across the western United States to locate the site for such a resort. The count spent months searching the mountains of the West and surveying many areas that would later become famous, but none of them met his strict criteria.

Late in his trip and on the verge of abandoning his search, he backtracked toward the Wood River Valley area in central Idaho. A Union Pacific employee in Boise had casually mentioned that the rail spur to Ketchum cost the company more money for snow removal than any other branch line, and the count went to explore. Schaffgotsch was overwhelmed by the area and wired his employer, saying: "This combines more delightful features than any place I have ever seen in Switzerland, Austria or the U.S. for a winter resort." Harriman visited several weeks later and agreed. The 3,888-acre Brass Ranch was purchased, and construction commenced that spring; it was built in seven months for $1.5 million. In the early years, movie stars, such as Clark Gable, Claudette Colbert, Gary Cooper, Ingrid Bergman, and others, came to the elegant, new winter resort. Over the years, the resort has attracted a more permanent population of talented professionals, including medical experts and information technologists, as well as those in the arts and entertainment industry. The success of the resort has resulted in tourism becoming the economic mainstay for the Wood River Valley that has lasted through to the present.

During all the years of shifting economic fortunes the community experienced, Hailey residents developed a culture that reflected their values and was in tune with the remarkable surroundings in which they lived. The importance they placed on their country's history and their role in it was reflected in the elaborate celebrations that commemorated the Fourth of July. The value they placed on the future was reflected in the excellent schools they constructed and staffed for their children. Of equal importance is the value the people of Hailey continue to place on the incredible natural beauty that surrounds them. From its earliest days, Hailey residents have taken time to enjoy hiking, hunting, fishing, camping, skiing, skating, riding, and any of the other pursuits that allow them to experience the amazing natural environment in which they live.

One

EARLY SETTLEMENT

Originally, gold brought prospectors to southern Idaho in the 1860s, but by the end of the 1870s, rich silver deposits had been discovered in the Wood River basin. Lack of nearby refining technologies for lead and silver, however, impeded mining development in the area until the 1880s when stage connections were completed to the smelting operations in Montana and Utah. By the mid-1880s, lead and sliver recovery operations boomed in the Wood River Valley, aided by the development of railroad lines across southern Idaho.

Former territorial congressman and stage owner John Hailey claimed several tracts of public land in the Wood River Valley in 1880. US Marshal Eben S. Chase, A.H. Boomer, and W.T. Riley also filed land claims in the area and joined with Hailey to form the Hailey Land Company. Hailey and his partners officially platted the Hailey townsite early in 1881. Because of its strategic location—mines filled the hillsides and gulches to the east and west—the little town developed quickly. A post office was granted on March 21, 1881, and later that year, following a hotly contested election, Hailey was named the seat of Alturas County.

The huge influx of miners and merchants led to a serious lumber shortage, which for a time meant buildings were constructed with hewn cottonwood logs found near the river and roofed with canvas. By the autumn of 1881, however, several new sawmills were in operation in the forested areas of the northern Wood River Valley. Even so, according to *For Wood River or Bust*, "a shortage of lumber was ongoing, and the Wood River towns would wear many of the canvas tops even into the next season."

By 1882, John Hailey and his business partners sold most of the Hailey townsite to the Idaho-Oregon Land Improvement Company (IOLIC), a subsidiary of the Union Pacific and Oregon Short Line railroad companies. The Oregon Short Line (which later became part of Union Pacific Railroad) laid its tracks across southern Idaho from 1881 to 1883 with a branch line built from Shoshone to Hailey in 1883. With the coming of the railroad, Hailey's fortunes were forever altered.

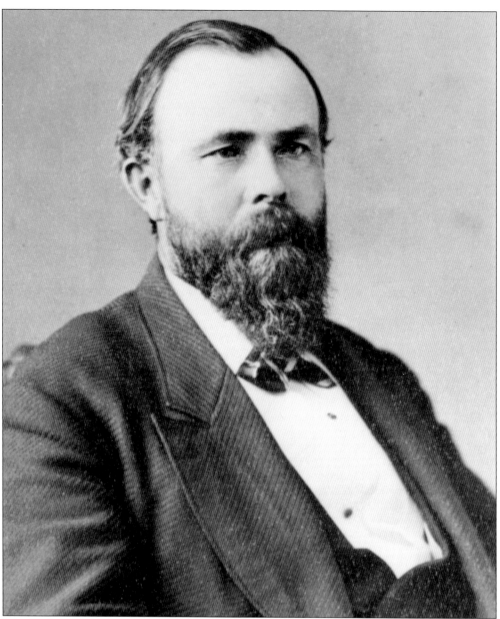

John Hailey, the town's namesake, was born in 1835 in Smith County, Tennessee. He moved with his family to Missouri in 1848 and at the age of 18 drove a team of oxen from the family farm to Salem, Oregon. There, he served as a volunteer in the Rogue River Indian War in Southern Oregon in 1855–1856, got married soon after the war was over, and followed the gold rush from Oregon to the Boise Basin in 1863. In southern Idaho, he engaged in agricultural pursuits, stock raising, and mining and was elected as a Democrat to the 43rd Congress (March 4, 1873–March 3, 1875). He then worked as a packer and stage driver and helped move US Army troops during the Bannock War of 1878. Following his land development activities and founding the city of Hailey, he was again elected to the Territorial Congress, serving from 1885 to 1887. He was later appointed warden of the Idaho Penitentiary in 1899 and served as the first curator and librarian of the Idaho State Historical Society in 1907. (Courtesy of the Idaho State Historical Society.)

John Hailey married Louisa M. Griffin on August 7, 1856, in Jackson County, Oregon. They had six children surviving to adulthood. Their fourth child, Thomas G., would serve in the Oregon Supreme Court. Their youngest son, George, pictured here, was a troubled youth who killed a man in Hailey at age 26, as described in the archives of the Blaine County Historical Museum website. (Courtesy of the Idaho State Historical Society.)

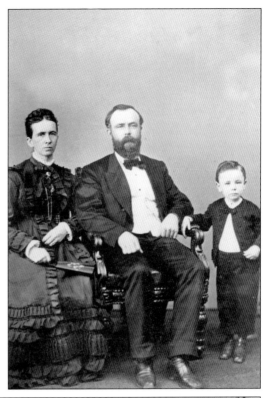

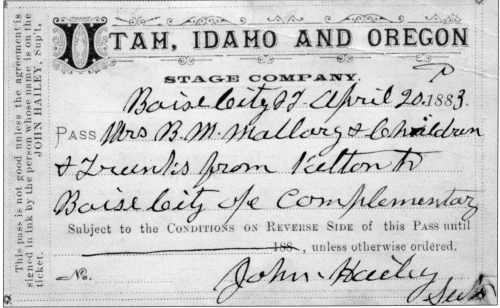

John Hailey was owner of the Utah, Idaho, and Oregon Stage Company. His stage line operated in Winnemucca, Kelton, Hailey, Silver City, and Boise. This ticket was issued to Mrs. B.M. Mallory (Sarah) and children to travel from Kelton, Utah, to Boise City. The route that would take them to Hailey would require eight days of travel. One of the children accompanying her was three-year-old Martyn. (Courtesy of the Blaine County Historical Museum.)

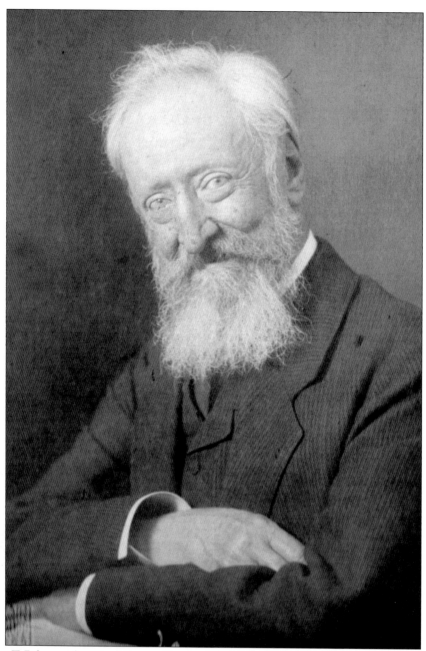

William T. Riley was born in Allegany County, New York, on March 31, 1843. Following the Civil War, he came west to Kelton, Utah, where he became an agent for the Wells Fargo and Company's Express, a stage line and agent for the local mail. While at Kelton, he met druggist J.J. Tracy and John Hailey, who was operating his own stage line in the area. Riley and Tracy moved to the Wood River area in late 1880 and set up the first drugstore in Bellevue. As the mining rush began in earnest, they relocated their business to Hailey where they erected a stockade building with tent roof at the northwest corner of what is now Main and Bullion Streets. At this same time, Riley entered into a partnership with John Hailey and took an active part in surveying and laying out the new town of Hailey. (Courtesy of the Blaine County Historical Museum.)

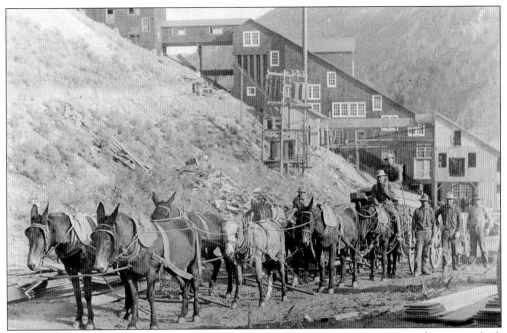

An eight-mule team is pulling a load of timbers, probably destined to be supports for a mine shaft at the North Star Mine, located 12 miles northeast of Hailey near the town of Triumph on the East Fork of the Wood River. According to the Idaho Geological Survey, "The mine was actively worked during the decade following 1883, and was credited with producing $800,000 worth of ore between 1883 and 1894." (Courtesy of the Blaine County Historical Museum.)

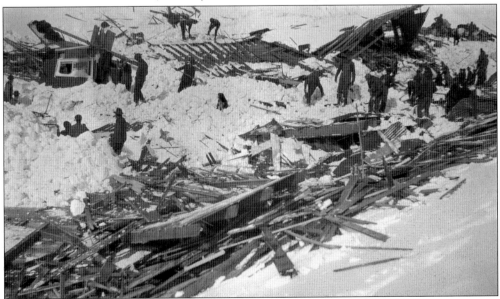

The North Star Mine disaster of February 25, 1917, began at about 3:30 a.m. when an avalanche destroyed the bunkhouse, killing 17 men and injuring 15. A fall of two and a half feet of snow during the previous three days followed by rain resulted in numerous slides in the district, many in places where they were never before known to occur. The victims were taken to Harris Furniture in Hailey, which served as a temporary morgue.

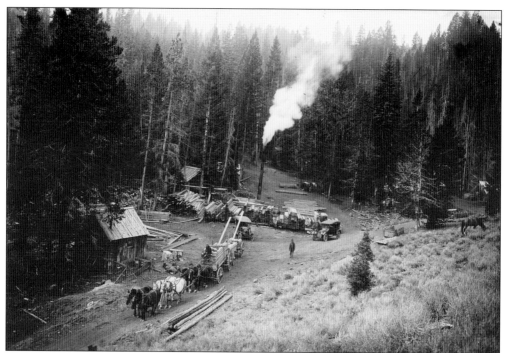

Logging and sawmill operations, such as this one located in the Sawtooth Mountains, were vital for the mining industry as well as town growth and development. The wagonload of fresh-cut lumber pulled by a six-horse team is probably destined for the rapidly growing population centers in the Wood River Valley.

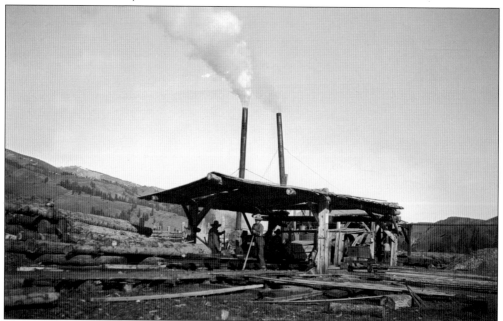

The construction of homes and businesses in the Wood River Valley as well as in the surrounding mines demanded huge amounts of lumber. Here, a steam-powered sawmill freed logging operations from being limited only to regions where streams provided power.

Two

COMMERCIAL
DEVELOPMENT

Hailey's population numbered between 300 and 400 its first winter. Many saloons, 20 lawyers, and all the necessary stores served the town in its heyday in the 1880s. Ernest Cramer, Charles A. Nelson, and J.C. Fox were among the first merchants who arrived in the spring of 1881. That year, Ernest Cramer erected the first commercial building located on the corner of River and Bullion Streets. Soon after, Charles A. Nelson and family arrived in Hailey and set up a livery on the west side of South Main Street, just north of where the forest service buildings are located today. Many years later, Francis Fox, wife of J.C., described what those early days were like in the 50th anniversary edition of the *Haley Times*:

> The tent office of the townsite company on River Street was a busy place. Business and residence lots were selling like hot cakes. Men in the town worked from early morn till sunset, clearing the sagebrush; digging cellars. The sound of hammer and saw could be heard from all directions.

Hailey's earliest daily newspaper, the *Wood River Daily Times*, was started by T.E. Picotte in May 1882. The paper was first issued in a tent, then in a log cabin with a dirt floor. Two log additions were added before the final frame building was erected.

According to *History of Alturas and Blaine Counties, Idaho*, the first telephone system in the Territory of Idado went into commission in Hailey on October 1, 1883. The exchange was in the Wood River Times Building on the southeast corner of Croy and Main Streets. Hailey was also the first city in Idaho to install an electric light plant. The first generator, powered by steam, was destroyed by fire in the summer of 1888. A new water-powered plant was erected west of the Wood River and a little below the Bullion Street Bridge. A dam was constructed across the river a short distance above the bridge and a canal dug from there to the plant.

Hailey's downtown continued to evolve through the end of the 19th and into the 20th centuries as businesses came and went, either by fire or economic necessity. But through it all, the optimism and energy displayed by those early pioneers is reflected through to the present day.

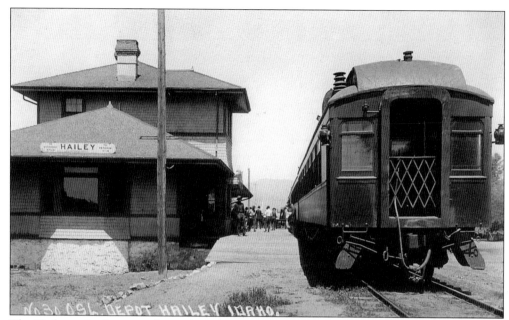

The Hailey train depot was located on the east side of town between Croy and Walnut Streets near where the bike path is now. The first train into Hailey was on May 23, 1883. Carrie Strahorn stated, "It was met with a brass band and all the enthusiasm of a Fourth of July." (Courtesy of the Blaine County Historical Museum.)

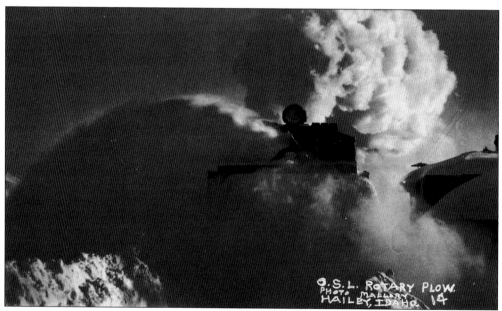

A train equipped with a rotary plow reaches the Hailey station. Before the rail line was completed in 1883, residents of Hailey faced weeks of isolation during the Wood River Valley's long, snowy winters.

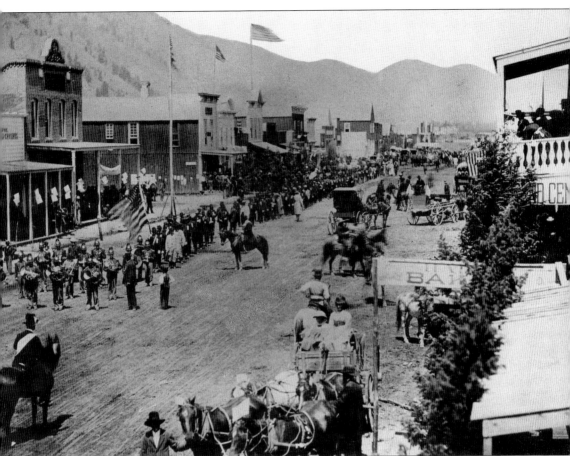

This view of Hailey's Main Street on July 4, 1883, looks to the northwest from a roof on the southern third of the block between Croy and Bullion Streets. The two-story brick building with the curved roofline in the upper left of the photograph was called the Bullion Block and located on the southwest corner of the intersection of Bullion and Main Streets. Spectators are enjoying the parade from the balcony of the Grand Central Hotel on the upper right of the photograph. Carrie Adell Strahorn had this to say about the hotel: "The walls and ceilings were only single boards covered tightly with cloth or paper, making a veritable sounding-board for every side of the room. I can never forget the first sensation of seeing the ceiling swaying up and down like the waves of the sea, and there seemed to be no mistake about either an earthquake swaying the house or that I was losing my mind." A fire destroyed the Grand Central Hotel and all other buildings in that block in September 1883. (Courtesy of the Idaho State Historical Society.)

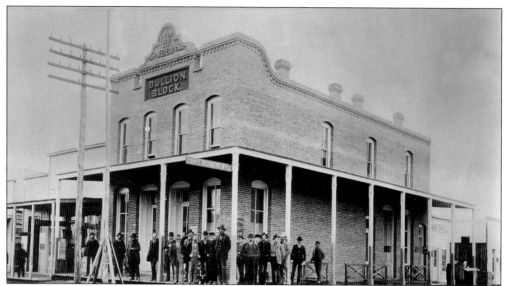

The Bullion Block Building was located on the southwest corner of Bullion and Main Streets (the location most recently occupied by North and Company). The building originally served as law offices for owners L.H. Woodin and Texas Angel. Following Hailey's selection as county seat, the building was rented by the county for $425 per month to be used as the Alturas County Courthouse with the basement used as the jail. The building was destroyed in the 1889 fire. (Courtesy of the Blaine County Historical Museum.)

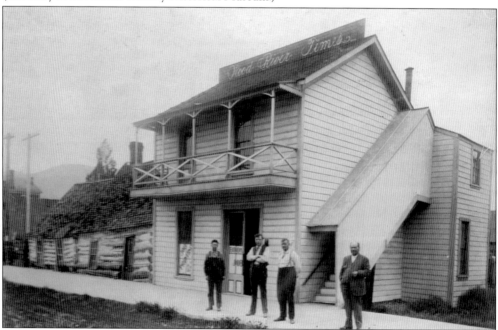

The Wood River Times Building was located on the southeast corner of Croy and Main Streets (across Croy Street from Shorty's Restaurant). The *Wood River Weekly Times* began publication in June 1881 with T.E. Picotte (on the right) as the editor. Until a printing press was purchased, its dispatches were initially wired to Blackfoot, and the papers were sent 175 miles back to the Hailey office by stage. (Courtesy of the Blaine County Historical Museum.)

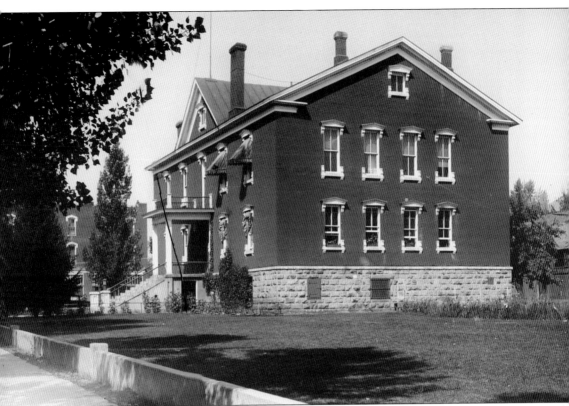

In February 1883, the Territorial Legislature approved the construction of a courthouse and jail at Hailey, the new county seat of Alturas County. In August 1883, the cornerstone was laid, and the offices were moved from the temporary courthouse at Bullion Block to their new home by August 1884. The cost of construction was $40,000, and the structure was considered the best courthouse in the territory at the time. The basement was constructed of rock, as was the jail. The steel cages in the jail reportedly cost $10,000. The other two stories were constructed of brick. For many years, the building served as offices for all the county officials with a large, up-to-date courtroom, jury room, and judge's chambers. In 1907, a two-story fireproof vault and a jury room on the third story were added.

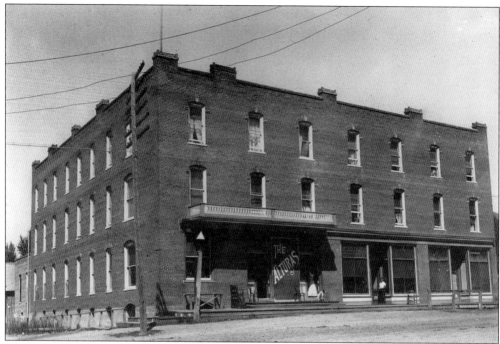

The Alturas Hotel (located on First Avenue and Croy Street where Atkinsons' Market is today) opened on May 25, 1886, with a grand ball. A Hailey newspaper of that date stated, "It is admitted to be the finest hotel between Denver and the Pacific Ocean." It was said to have cost $35,000 with $8,000 in furniture, not including the $5,000 bar and fixtures connected with the billiard hall. (Courtesy of the Blaine County Historical Museum.)

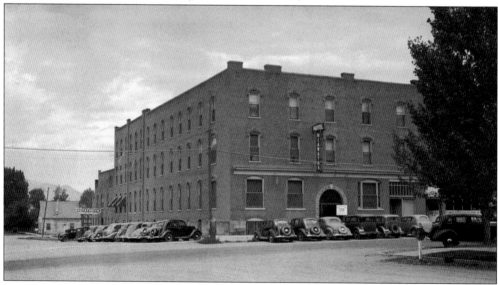

On August 13, 1913, the Alturas Hotel was sold to the Hiawatha Land and Water Company. It was extensively remodeled before reopening under its new name of Hiawatha. Each room was equipped with natural hot water heating, supplied from the hot springs two and a half miles west of town. The hotel also boasted an enclosed hot water natatorium where many locals first learned to swim. The Hotel Hiawatha was destroyed by fire in 1979.

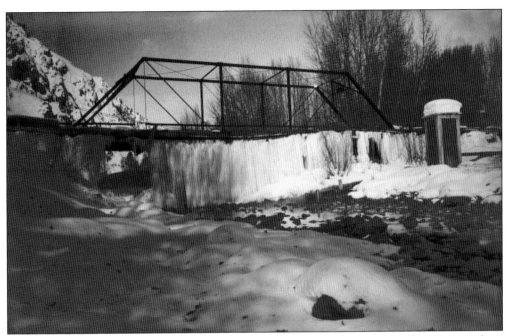

The curtain of ice along the base of this bridge over the Big Wood River on Bullion Street is from seepage from the wooden pipe used to carry hot water from Hailey Hot Springs to the Hiawatha Hotel in downtown Hailey. Carbonate Mountain can be seen at the left side of the photograph.

The Hiawatha Hotel Natatorium boasted "natural hot water baths" on its sign on the west side of the hotel on First Avenue around 1930. This view of First Avenue, looking north from the west side of the hotel, is much different than the entrance and parking lot for Atkinsons' Market that exists in this location today.

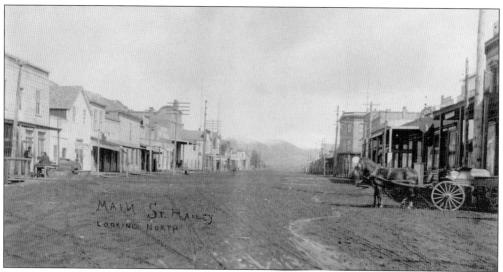

In this mid-1880s view looking north from the Croy Street intersection, the buildings on the left side of Main Street are generally made of wood, having survived the 1883 fire that razed all the buildings on the opposite side of the street. A notable exception is the curved roof, brick Bullion Block near the center of the photograph. (Courtesy of the Blaine County Historical Museum.)

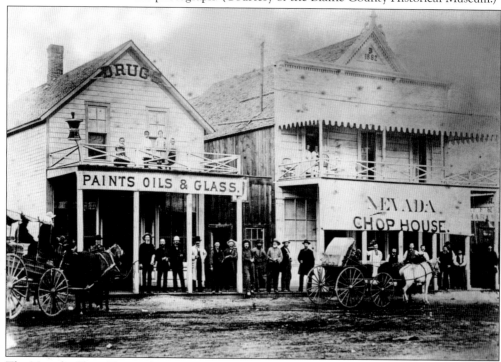

The Nevada Chop House, shown around 1885, was located near the corner of Carbonate and Main Streets where Christopher and Company is now located. According to the *News-Miner*, a suspicious man whose face was "bound up with a napkin . . . claiming to be suffering from neuralgia" left his room on the second floor shortly before fire was discovered there around 1:00 a.m. on July 2, 1889. The fire eventually destroyed the entire business district. (Courtesy of the Idaho State Historical Society.)

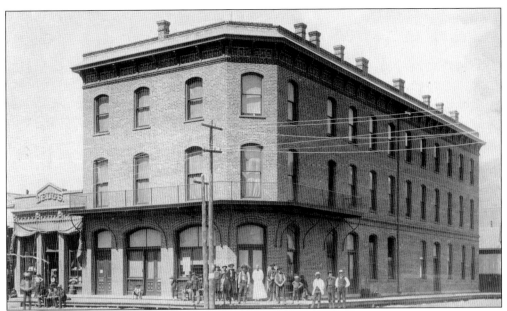

The Merchants' Hotel on the northeast corner of Bullion and Main Streets was one of the biggest losses in the fire of 1889. It had just held its formal opening on November 10, 1887, with a grand ball and banquet in its spacious dining room. The building was completely gutted, causing the brick wall to collapse outwardly, filling the entire street with hot, falling bricks. (Courtesy of John and Joan Davies.)

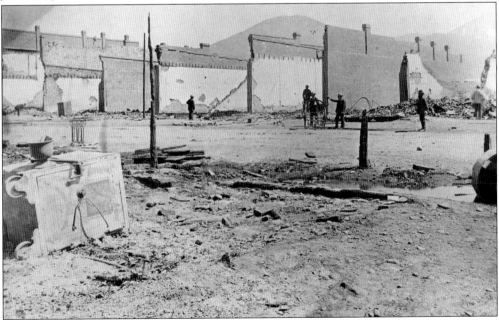

The aftermath of the July 2, 1889, fire is seen from the corner of Croy and Main Streets looking northeast. Nothing but ashes and a few metal objects remain on the west side of Main Street. Across the street are remnants of the walls of the brick buildings constructed only six years before. The entire four-block business district on both sides of Main Street from Croy to Carbonate Streets was destroyed. (Courtesy of the Idaho State Historical Society.)

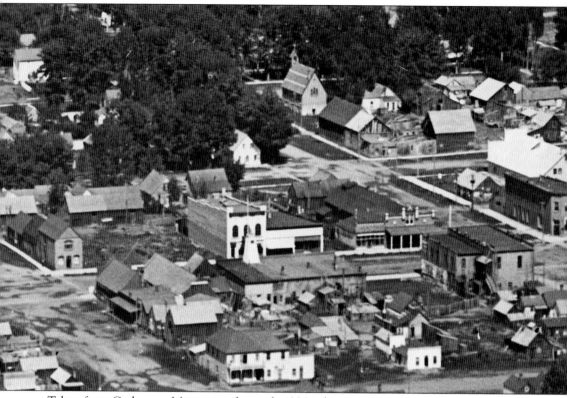

Taken from Carbonate Mountain, this early-1900s photograph gives a panoramic view of the Hailey downtown from Carbonate Street on the left to Walnut Street on the far right. Prominent landmarks include the Alturas Hotel (mid-photograph near the top, now Atkinsons' Market), the courthouse at the intersection of First Avenue and Croy Street (across the street to the right of the Alturas Hotel), the Watt Building on Main Street (near the left edge of the photograph,

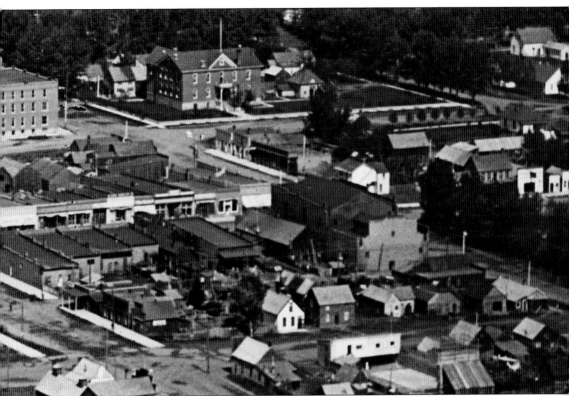

now Christopher and Company), and the Episcopal Church (near the top of the photograph to the left of the Alturas Hotel). The Wood River Times Building can be seen just peaking over the Odd Fellows Hall on the corner of Croy and Main Streets. The J.C. Fox Building (now housing city hall and the library) has not yet been built.

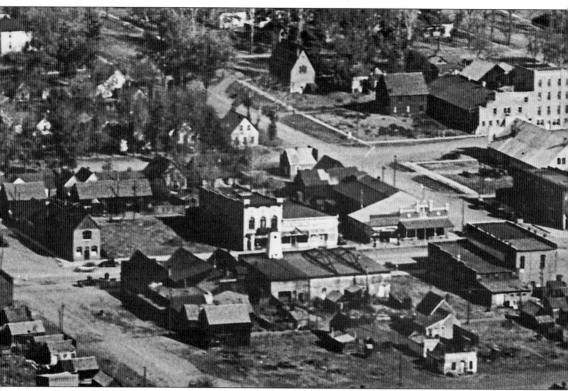

The changes in downtown Hailey can be seen in this later panoramic view of the area taken from Carbonate Mountain in the 1920s or early 1930s. The Hiawatha Hotel (formerly the Alturas) with its lighter-colored additions, including the natatorium (at the center top of the photograph), can be compared to the earlier photograph on the previous page. The J.C. Fox Building has been

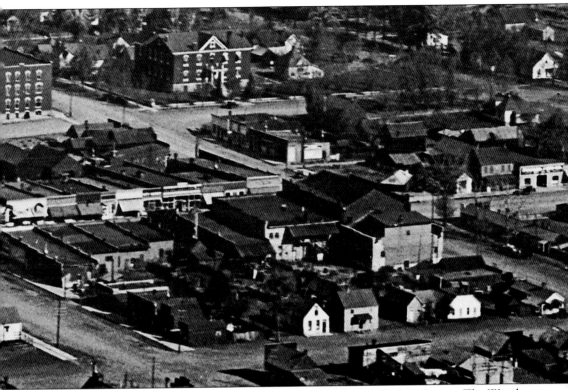

constructed next to the Odd Fellows Hall near the corner of Croy and Main Streets. The Wood River Times Building, which was on the southeast corner of Main and Croy Streets, has been replaced by a service station.

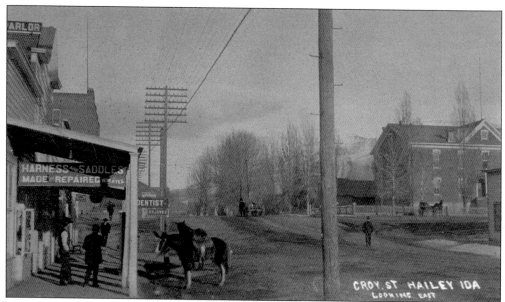

Looking east on Croy Street in December 1905, M.W. Kyes Harness and Saddle Shop is located where ColorTyme and Flolo's Imaging Center are now. The courthouse is on the right of the photograph, and a large number of telephone and power lines are running overhead. Horses and buggies were the main means of transportation during this period. (Courtesy of the Blaine County Historical Museum.)

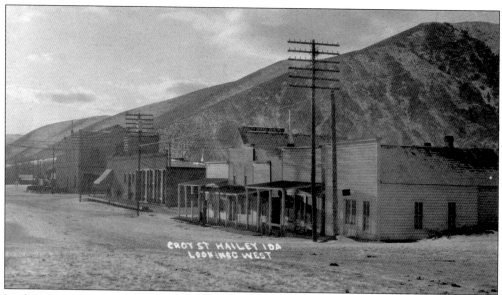

Looking northwest on Croy Street toward Main Street in December 1905, a dental office can be seen in the second building from the alley, which runs behind Baugh's Drugstore on the corner of Croy and Main Streets (where Shorty's is now located). Carbonate Mountain rises impressively in the background. The Odd Fellows Hall is visible across the street from the drugstore. (Courtesy of the Blaine County Historical Museum.)

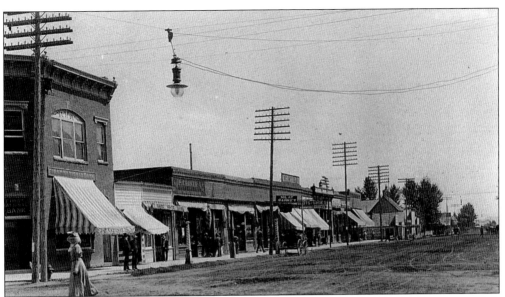

Pictured around 1900, this is Main Street looking southeast from the middle of its intersection with Bullion Street. Large bank buildings on Main Street apparently have a long history in the valley, as evidenced by the impressive First National Bank Building on the corner where the Wells Fargo Bank is located today. (Courtesy of the Blaine County Historical Museum.)

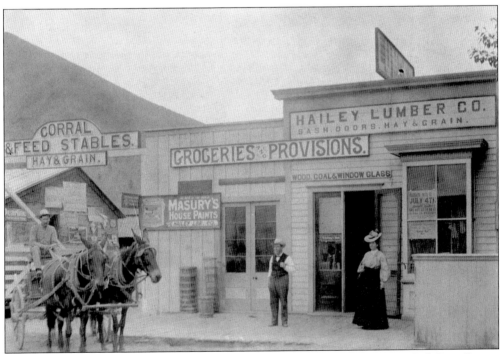

The Hailey Lumber Company was located on the southwest corner of Main and Croy Streets around the early 1900s (where the Hailey Hotel is located today). Lumberyards apparently also carried groceries and provisions in those early days. A sign promoting the Fourth of July horse races and grand ball is visible in the window on the right.

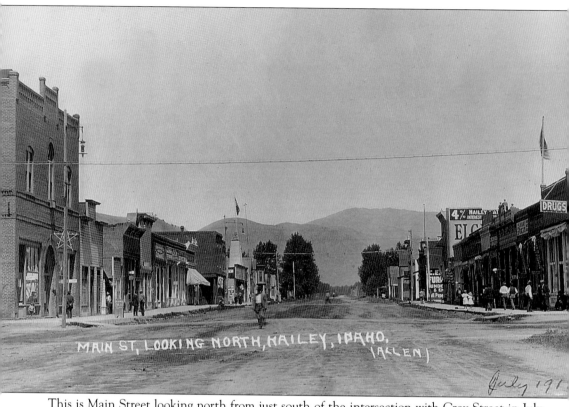

This is Main Street looking north from just south of the intersection with Croy Street in July 1913. The Odd Fellows Hall, often referred to as the "Opera House," is on the northwest corner on the left of the photograph. Hailey's city hall and public library now occupy that corner. The Aukema Drugstore (purchased by Mark Aukema from John C. Baugh the previous year) is just across the street on the northeast corner. The J.J. Tracy Building (Barkin' Basement) with its distinctive cornice can be seen fourth building up on the left. The white, tower-like structure (on the left side of Main Street near the center of the photograph) displaying a flag on a pole holds the fire alarm bell. The tower is part of the firehouse situated in the middle of the block between Bullion and Carbonate Streets. No doubt, many adults living in Hailey at this time remembered the disastrous fire of 1889. (Courtesy of the Blaine County Historical Museum.)

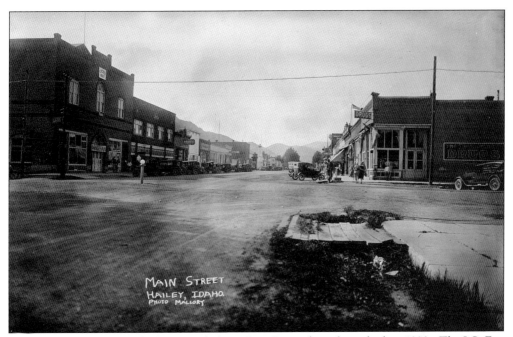

This view of Main Street looking north from Croy Street dates from the late 1920s. The J.C. Fox Building sits between the Odd Fellows Hall and the J.J. Tracy Building (Barkin' Basement) very much as it looks today. In this view, the Hailey Water Company occupied the lower floor of the Odd Fellows Hall, and a dentist office was located in the J.C. Fox Building.

This young family is out for a drive in their horse-drawn buggy on north Main Street around the 1890s. The Watt Building (now Christopher and Company) on the southeast corner of Carbonate and Main Streets is visible in the background.

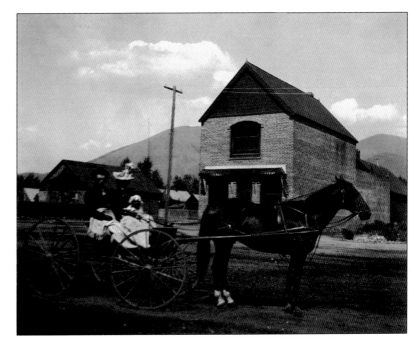

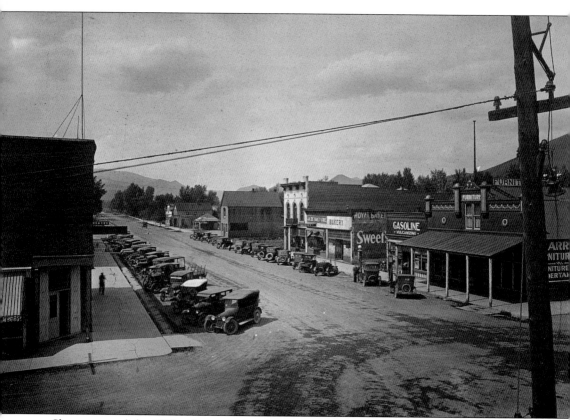

Shown around the 1920s, the east side of Main Street from Bullion Street to Carbonate Street and beyond is viewed from the roof of the Werthheimer Building (present location of the former North and Company) at the southwest corner of Bullion and Main Streets. The ornate Harris Furniture Building on the northeast corner of the intersection is located on the former site of the Merchants' Hotel. Adjoining the Harris Building to the north is a service station, an open lot, a former bakery, and Jacobs' Variety Store. Both the bakery and variety store buildings, whose exteriors have changed very little since that time, are presently occupied by the Taste of Thai restaurant. Adjoining the variety store is the striking Commercial Building with its balcony, elaborate white-brick facing, and cornices. Farther to the north are several vacant lots remaining from the fire of 1889, followed by the Watt Building, which from 1912 to 1967 served as the medical office of Dr. Robert Wright, one of Hailey's most beloved physicians.

S.J. Friedman was one of Hailey's early pioneer retailers. Born in Germany, Friedman ran a store in the mining town of Silver Reef in southern Utah before coming to Hailey. With its sod-layered roof and steel shutters, his building was one of the few to survive the fire of 1889. The *Wood River News-Miner* of July 5, 1889, quotes Friedman while the flames swirled around his store: "Shesus, see the old synagogue stand the test."

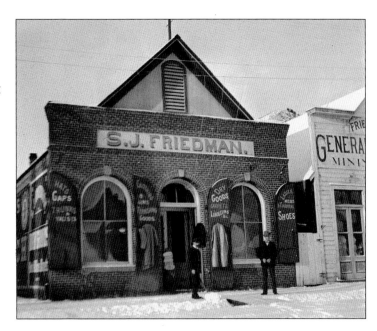

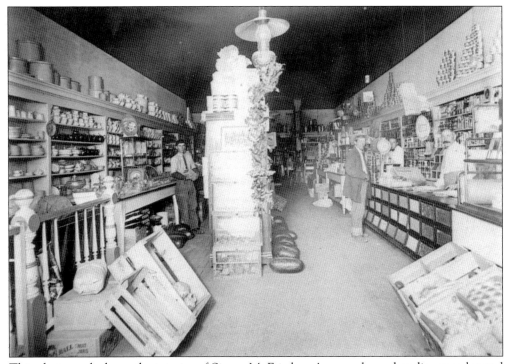

This photograph shows the interior of Simon M. Friedman's general merchandise store located on the southwest corner of Carbonate and Main Streets around 1910. Simon M. Friedman, S.J. Friedman's cousin, was Hailey's first mayor, serving two terms. The Friedman Memorial Airport land was donated to the city of Hailey by his son Leon and daughter Lucile. S.M. is behind the counter on the right. (Courtesy of the Blaine County Historical Museum.)

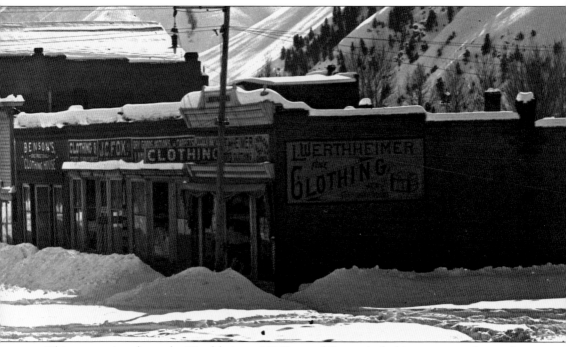

This snowy view shows the Werthheimer, J.C. Fox, and Benson's clothing stores on the southwest corner of Bullion and Main Streets around 1910. Following the fire of 1889, which destroyed all the buildings on this block, Leopold Werthheimer and J.C. Fox built the four-unit complex shown in the photograph. Werthheimer reopened his business, most recently the home of North and Company, on the site of his former store that had been located in the Bullion Block Building. J.C. Fox took the next two units, presently the home of the Golden Rule Building, and the fourth was occupied by Benson's Clothing House. In recent years, that building has held the Red Elephant Saloon and the Main Street Bistro.

Leopold Werthheimer was born in Germany in 1854 and immigrated to the United States in 1872. After spending two years in New York, he moved to Cheyenne, Wyoming, and entered the clothing trade with his uncle. At the age of 30, he moved to Hailey and opened his own men's clothing and furnishings store in the Bullion Block. He was able to buy the building four years later. (Courtesy of the Blaine County Historical Museum.)

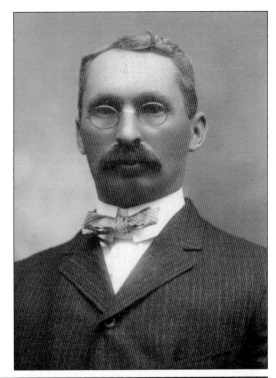

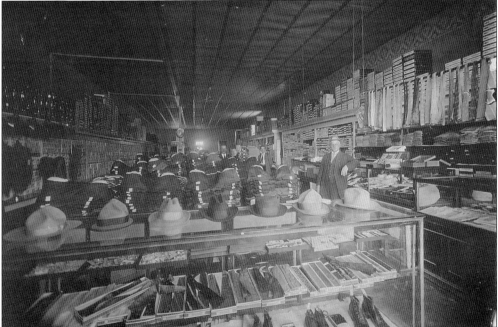

Leopold Werthheimer (center) peers out from behind piles of trousers inside his men's clothing store. At the time of his death, he donated $1,000 to the city of Hailey for improvements to the park at the south edge of town, the present home of the Hailey Rodeo Park. Since that time, the property has officially been known as Werthheimer Park. (Courtesy of the Blaine County Historical Museum.)

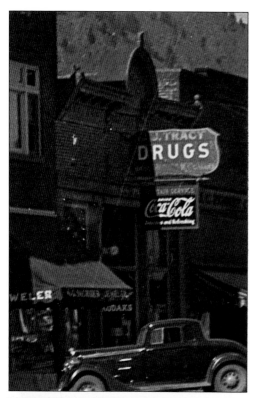

J.J. Tracy constructed this building in 1906; he operated a drugstore there until his death in 1932, becoming the longest continuous serving merchant in Hailey. His sister and niece ran the drugstore for several more years until it was sold to Otto Broyles, whose family operated a pharmacy there until the 1980s.

The well-stocked shelves inside J.J. Tracy's store on Main Street are shown around 1910. Throughout Hailey's 130-year history, the quaint downtown district has continuously evolved as businesses have come and gone. For over 100 years, however, the J.J. Tracy Building has been a prominent fixture of Hailey's Main Street, serving as a remarkable connection to Hailey's pioneer past. (Courtesy of the Blaine County Historical Museum.)

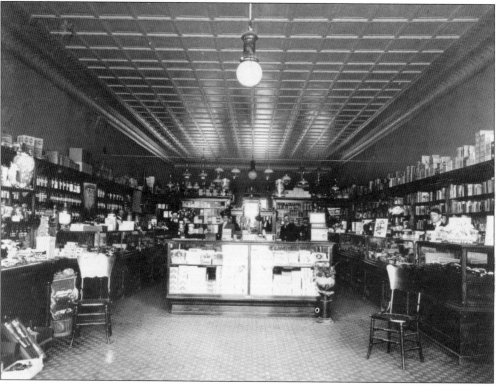

This prominent downtown landmark was built shortly after the 1889 fire destroyed French's saloon on the corner of Bullion and Main Streets. The original wall from the old saloon can still be seen in the back parking lot of the current Wells Fargo Bank Building. (Courtesy of the Blaine County Historical Museum.)

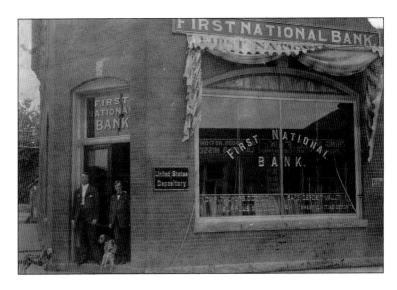

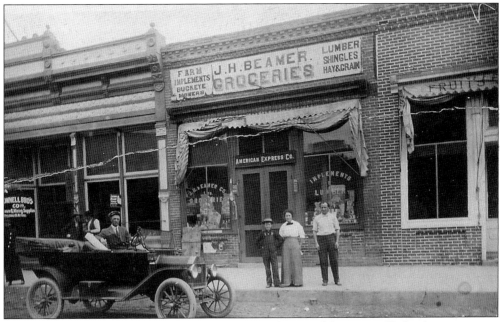

Shown around 1915, the Beamer grocery store was a fixture of downtown Hailey for many years. Grocery stores of that time carried much more than groceries, as can be seen on the various signs on the building. The store was located two doors to the north of Aukema Drug on the northeast side of Croy and Main Streets around where the Mitchel Building is located today. (Courtesy of the Blaine County Historical Museum.)

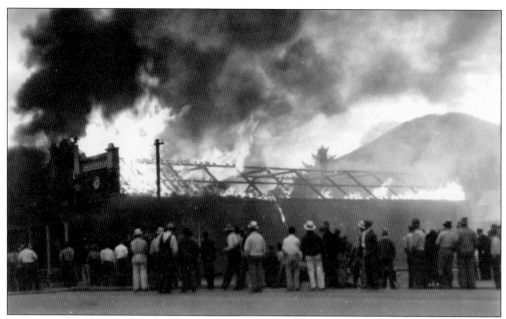

The Harris Furniture Building was destroyed by fire on July 31, 1935. At the time, Lena J. Harris and son Charles were operating the family business, originally opened at the northeast corner of Bullion and Main Streets in 1899 by Charles A. Harris. Bricks salvaged from the fire were used by architect and builder Jack Rutter in construction of the new store. Windermere Real Estate currently occupies the building. (Courtesy of the Blaine County Historical Museum.)

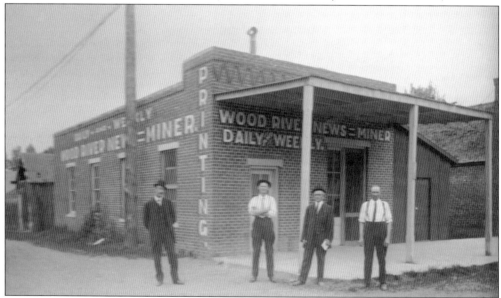

During the late 1800s, no less than four daily papers were in circulation in Hailey. Over the years, consolidations and buyouts reduced that number. The *Wood River News-Miner* was one result of those consolidations. This photograph, taken around the 1920s, shows the office located west of Main Street on Bullion Street behind Werthheimer's clothing store (formerly North and Company) in the building presently occupied by the Red Door Design Store. (Courtesy of the Blaine County Historical Museum.)

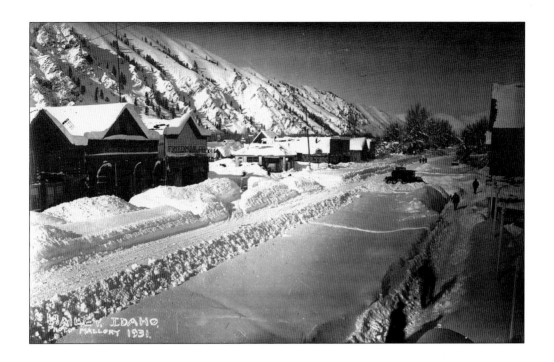

These two photographs were taken from the balcony of the Commercial Building following a major snowstorm in the winter of 1931. Clearly, Hailey had not developed the level of sophistication in snow removal that today's residents have come to expect. The picture above shows the view looking north on Main Street. The S.J. and S.M. Friedman Buildings are visible left of center on the west side of Main Street. The Hailey Service Station across Carbonate Street on the corner appears quite snowed in. The photograph below shows the view looking south on Main Street. Perhaps in keeping with the holiday season, there is a large evergreen tree with a flagpole mounted in the snow pile in the center of the Bullion and Main Streets intersection.

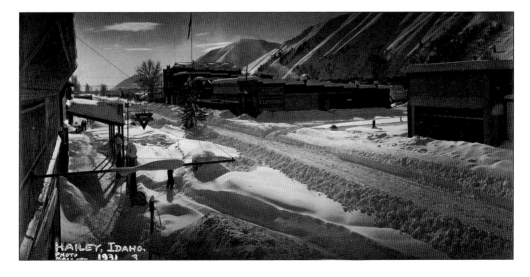

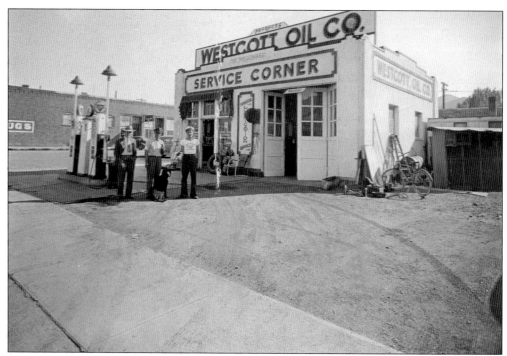

Shown are the southeast and southwest corners of Croy and Main Streets as they appeared in the mid-1930s. The Wescott Oil Company (proprietor Les Outzs) is located on the corner that earlier held the Wood River Times Building (see page 18). Across the street to the north, the Aukema Drugstore is visible in the background. The photograph below shows the Rialto Hotel. It was built originally as a Basque boardinghouse by Jack Rutter for Jullio and Maria Astorquia. The Astorquia family owned the Rialto Hotel until 1973, making it the longest operating Basque boardinghouse in Blaine County. The building has since been used as a bar and restaurant and was renamed the Hailey Hotel in 1980. (Above, courtesy of the Blaine County Historical Museum.)

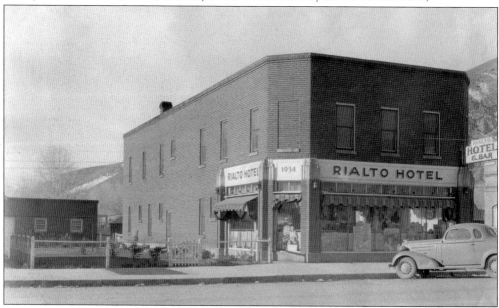

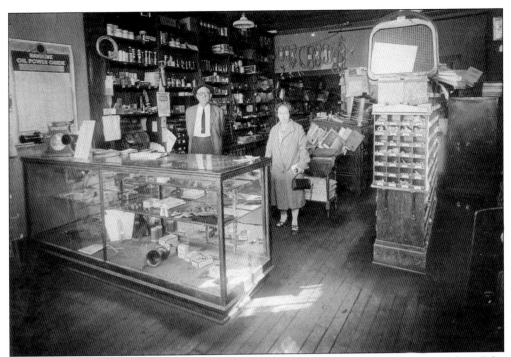

Around 1930, the Fowler Auto Company was located on South Main Street in the center of the block between Croy and Walnut Streets, about where Hailey Auto Exchange is located today. A Mr. Fowler (left) ran the Buick dealership in town. Nettie Mallory, sister of amateur photographer Martyn Mallory, is on the right.

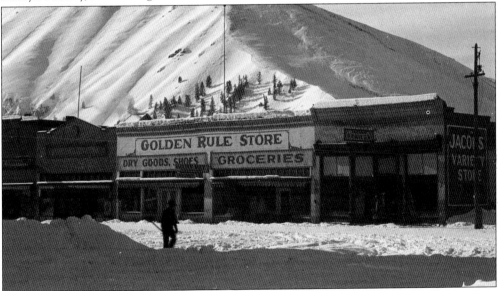

Seen from the intersection of Bullion and Main Streets looking southwest, the Golden Rule Store is pictured in the late 1920s. McClain's Pizzeria presently occupies the left side of this double building originally constructed by J.C. Fox. Jacobs Variety Store, most recently North and Company, occupies the former Werthheimer clothing store. A snow-covered Della Mountain is visible in the background.

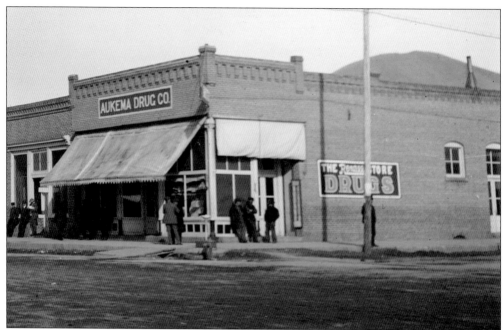

After working as an apprentice for John C. Baugh for several years, Mark Aukema purchased the building located on the northeast corner of Croy and Main Streets from his former employer in 1912 and gave his name to the business. In 1952, Aukema sold the drugstore to his son Edgar M. Andrews. The building went on to house the Opportunity Shop for several years and held a 24-hour dry cleaning business when the photograph below was taken in the 1970s. In the 1990s, actor Bruce Willis bought the property, razed the building, and replaced it with the E.G. Willis Building, which houses the popular Shorty's Diner. (Below, courtesy of the Blaine County Historical Museum.)

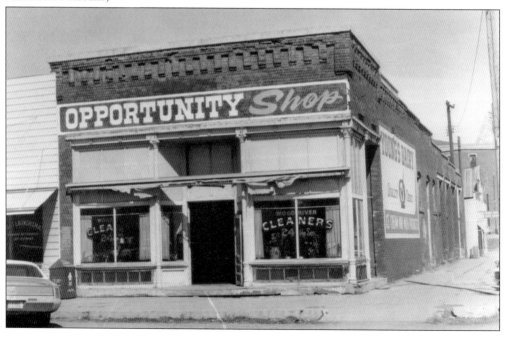

Three

EARLY LIFE IN HAILEY

There was a lot more going on in and around Hailey than what was happening on Main Street. Homes were built. People settled in and made lives for themselves. There were the common and unique details of small-town life in the western mountains.

According to Madeline Buckendorf, the Hailey townsite included 144 blocks, most of which were bisected by alleys. "The lots were long and narrow with the commercial ones measuring 30 feet by 120 feet. The residential lots, measuring 20 feet by 120 feet, had building setbacks of 25 feet from the dusty streets. The number of residential lots owned by each family varied greatly from one to five lots in some instances. As was the case in most Idaho towns, the plat did not include a town square."

Successful businessmen favored corner lots in the residential section for their homes. "By 1886, Eben S. Chase, William T. Riley, Charles B. Fox, the Friedman cousins, John C. Fox, Francis E. Ensign, and Homer Pound (father of poet Ezra Pound) had homes built on corner lots in this area. Housing development between the corner lots varied greatly from empty spaces to small houses crowded closely together on single lots."

Although the bricks, boards, and mortar provide an idea of how people lived, viewing actual people engaged in everyday pursuits helps to "fill in the blanks" of what life in Hailey might have been like during the late 1800s and early 1900s.

Members of the Beamer family ran a successful lumber business in town. Their lovely home on the southeast corner of Croy Street and Fourth Avenue can still be seen today, looking much as it did in the early 1900s. (Courtesy of the Blaine County Historical Museum.)

Dr. Plummer was one of Hailey's first physicians. This home was located on the southeast corner of Third Avenue and Walnut Street.

W.F. Horne was a partner of the successful mercantile firm Campbell, Horne, and Holland that operated on Main Street. His home was located on Third Avenue and Carbonate Streets. W.F. Horne's first son, William Hailey Horne, married Mabel Mallory, younger sister of Martyn Mallory, and his third son, Robert Ray, was the father of Roberta McKercher and Billie Buhler, both well-known residents of Hailey. (Courtesy of the Blaine County Historical Museum.)

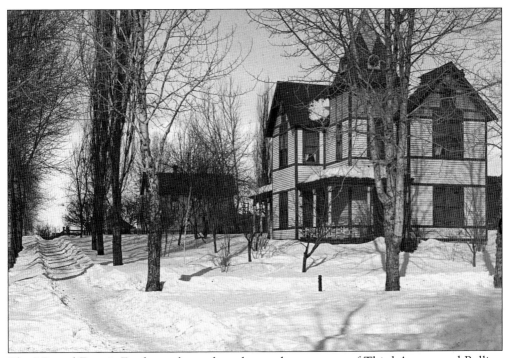

The J.C. and Francis Fox house located on the northeast corner of Third Avenue and Bullion Streets was constructed in 1882–1883. It was a two-story, L-shaped, gable-and-wing house with a Queen Anne–influenced square turret tucked in the L. Fire destroyed the building in 1946.

Simon M. Friedman's elegant home was built around a log cabin core originally constructed in 1885. It was turned into a two-story, Queen Anne–style home clad with fancy-cut shingles. This photograph was taken in the early morning following a heavy snow in Hailey. The house still stands at the northwest corner of Silver Street and North Third Avenue.

W.T. Riley's home was located on the southeast corner of Bullion Street and Second Avenue. This house was a one-and-a-half story, T-shaped, side-gable-and-wing form with dormers projecting from the half-story roof area. The house burned down in the 1920s and was replaced in the 1930s by the Hailey Masonic Lodge. (Courtesy of the Blaine County Historical Museum.)

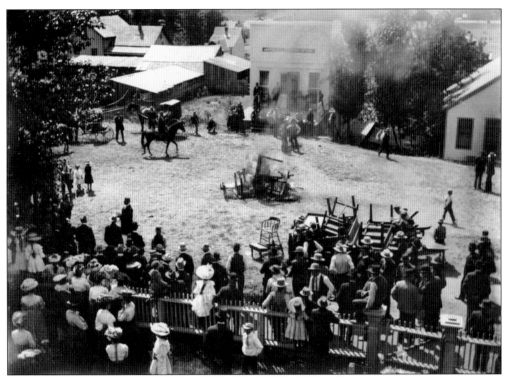

This image shows the burning of the gaming tables in front of the courthouse around 1900. A variety of stories have accompanied this photograph over the years, most having something to do with the temperance movement. The gambling equipment came from saloons and was a tangible symbol of the "evils" of alcohol.

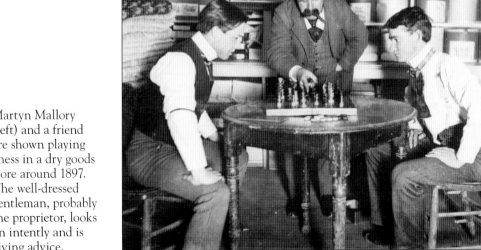

Martyn Mallory (left) and a friend are shown playing chess in a dry goods store around 1897. The well-dressed gentleman, probably the proprietor, looks on intently and is giving advice.

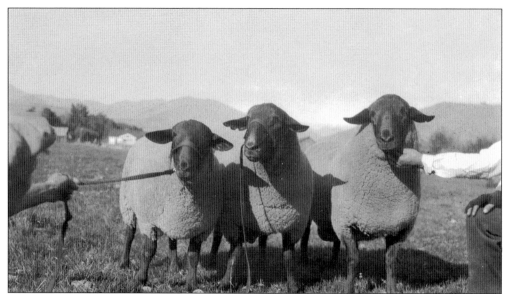

Sheep ranching was a major industry throughout Idaho in the early 1900s. John Hailey was one of the biggest sheep ranchers in the Wood River Valley. This photograph shows three Suffolk sheep, a breed developed in England that was very successful in the high desert of south central Idaho.

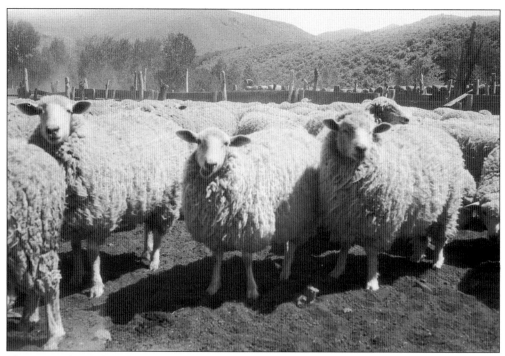

Sheep were herded to the high mountain meadows every spring and returned to the southern parts of the state in the fall. Here, a large flock of sheep is being held in a corral in the Wood River Valley. Before the 1970s, sheep far outnumbered humans in Idaho.

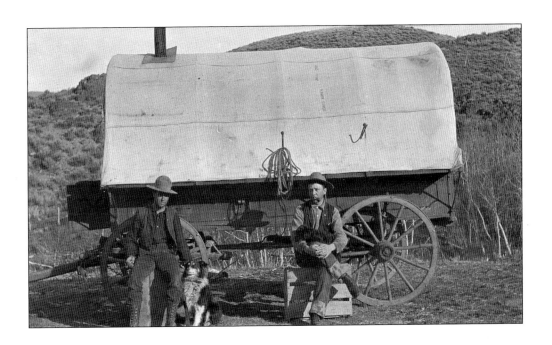

Sheep wagons provided a home away from home for sheepherders for months out of the year. The smokestack in the photograph above, taken around the 1920s, shows the wood-burning stove that served to cook meals and provide warmth on chilly mornings in the high mountain meadows. The sheep dog was a valuable partner in the enterprise. Dogs could chase off or warn the shepherd of predators as well as help control a flock of 2,000 sheep spread out among the sagebrush. Many shepherds during this period were Basque immigrants. The Basque men were willing to tolerate the trying conditions associated with the hard work and long periods of loneliness involved with herding sheep. When they were able to take the time to come into town, several Basque boardinghouses in Hailey would provide a place where they could go to feel closer to their homeland.

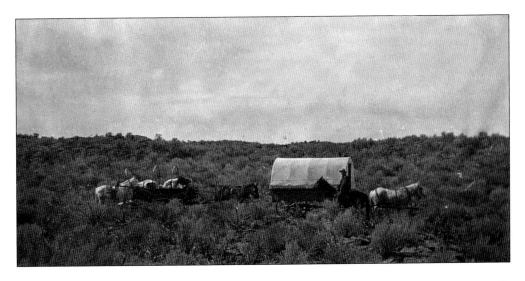

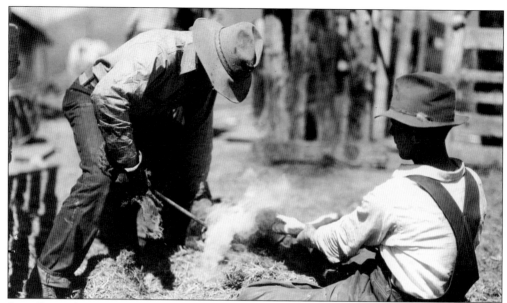

Initially, cattle were the major livestock produced in Idaho. But the dry range conditions proved to be ideal for sheep, and they eventually came to dominate the landscape. In this photograph, a pair of cattle ranchers brands a calf.

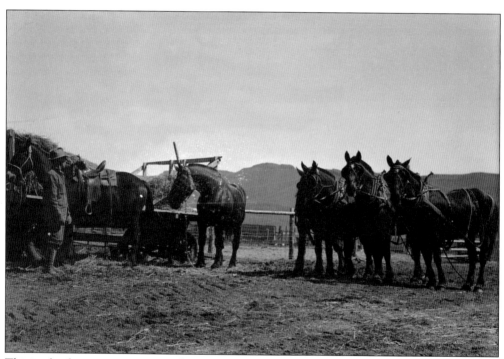

This is what horsepower meant in the early 1900s. This group of fine-looking draft horses provided the muscle to plow the fields and haul the wagons in the fertile but rocky bottomlands of the Wood River Valley.

A proud mother and her three lovely daughters take time out from the Fourth of July celebrations to sit for a photograph in the 1890s. The excitement in the faces of the three girls is apparent.

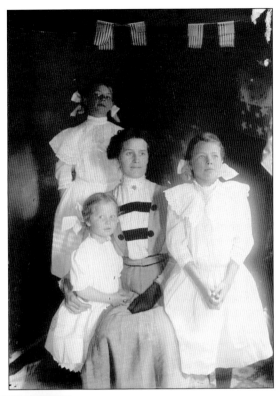

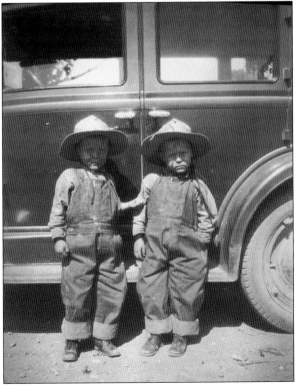

Always a special event whether today or in the 1930s, having twins calls for identical outfits. These two identical twin boys are clearly dressed to go to work on the farm.

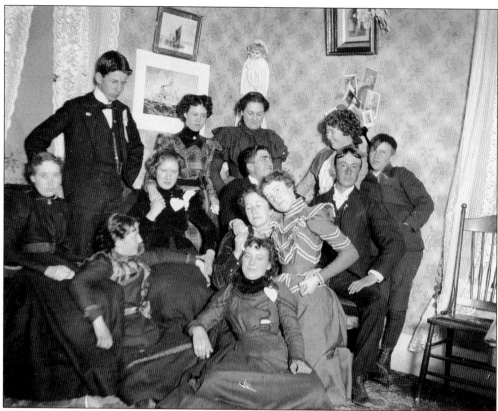

Then, as now, there is always something going on in the valley. Mable Mallory (third row, second from the left) and a group of young friends are dressed for a formal occasion.

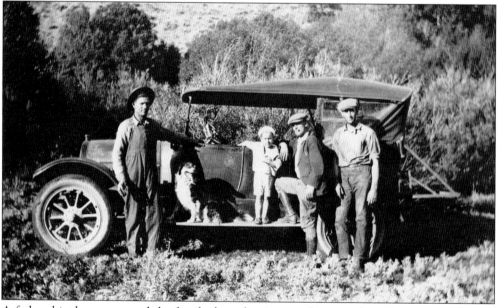

A father, his three sons, and the family dog take time out from ranch work to pose with their automobile somewhere out in the country around 1930.

Hailey has been a "dog town" since its earliest days. This woman is wearing the "black silks" considered essential for women of means in Hailey while out on the town on business in the late 1800s. Her somewhat stern look is showing the dog she means business.

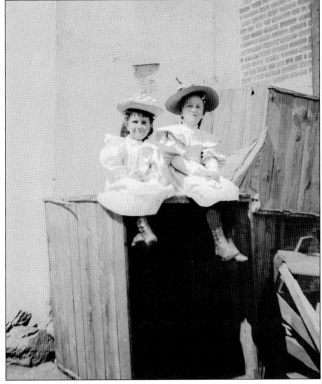

Showing looks of great satisfaction, two young ladies in their starched white dresses and hats take time out from a summer formal occasion, such as the Fourth of July. One wonders how long those white dresses stayed clean in the dusty conditions of town in the early 1900s.

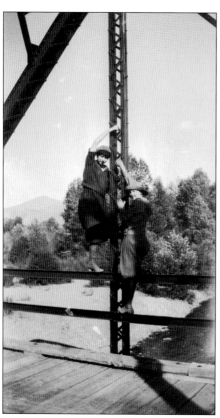

These two young women are posing on a bridge around the 1920s. Their outfits, including tall leather boots, suggest they are prepared for some serious outdoor activities.

These four friends are out for a stroll on the dusty streets of town around the 1890s. The group appears to be sharing a light moment. Some streets in Hailey were not paved until well into the 1960s.

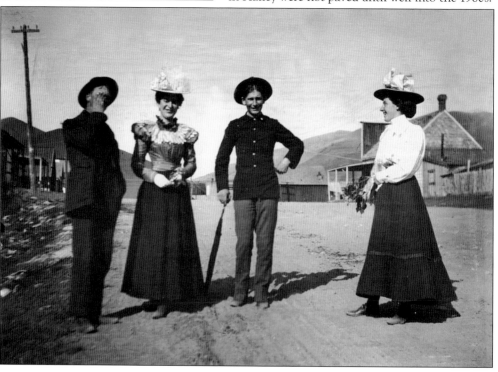

A well-dressed lad stands on a front porch holding his hat around 1900. He may be Martyn Mallory's nephew Meredith, born in 1898.

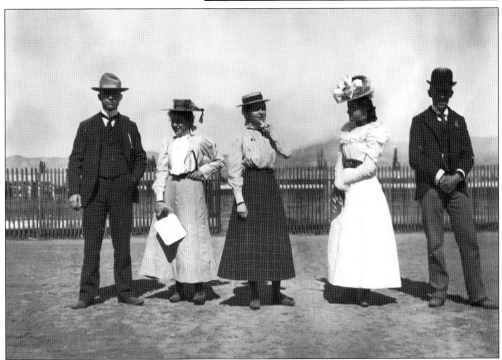

These five young adults are posing in their business clothes in the early 1900s.

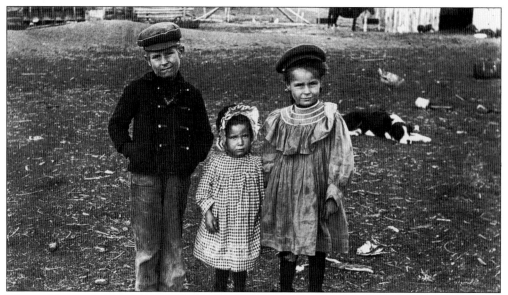

Three siblings take a break from chores for a photograph, taken in the early 1900s. The family dog looks on, and a chicken scratches in the background.

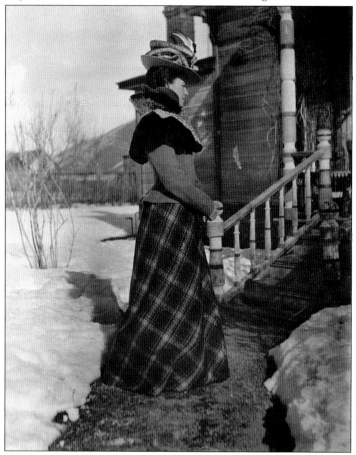

A finely dressed woman from about the 1890s approaches the front steps of a home on Fourth Avenue in Hailey in early spring. The house once served as the parsonage for the Episcopal Church.

A dapper Martyn
Mallory, perhaps on his
way to work, poses for a
photograph around 1900.

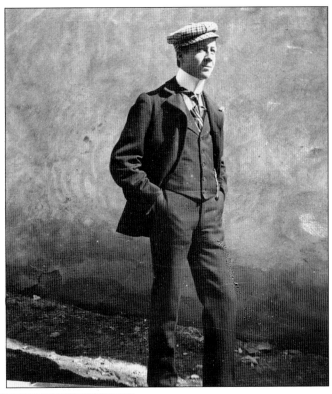

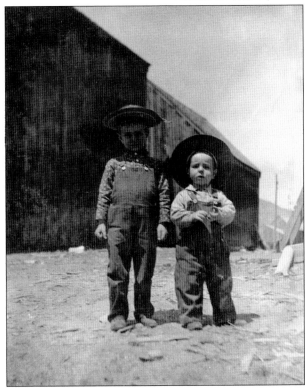

These two young lads pose
in their play clothes in an
alley somewhere in a Hailey
neighborhood around 1900.

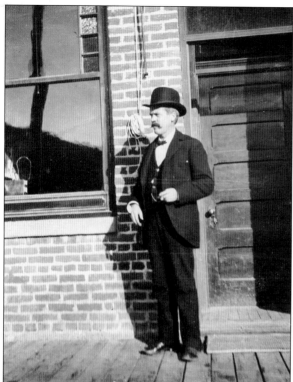

The front entrance to the Watt Building (presently Christopher and Company) in downtown Hailey is pictured around 1900, showing the boardwalk it had in its earlier days. With dirt streets that would almost always be muddy or dusty, the boardwalk offered both this well-dressed gentleman (possibly Dr. Wright) and the Main Street businesses a chance to stay just a little bit cleaner.

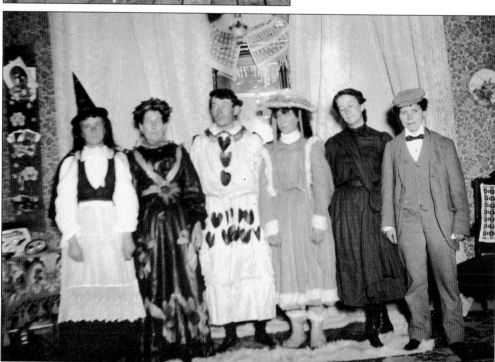

Hailey has always been a town that knows how to make its own fun. Occasions to dress up and enjoy a costume have not always been confined to Halloween.

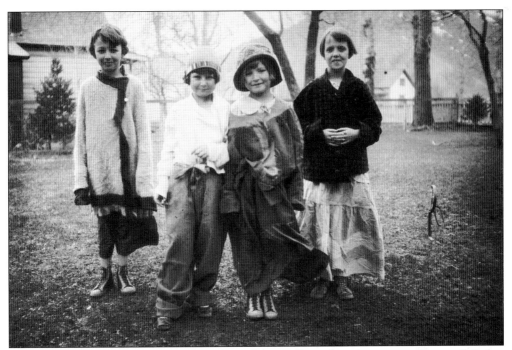

Martyn Mallory's daughter Jean, on the right, and three of her pals strike a pose in "dress-up" clothes for a photograph in the Mallory's front yard on First Avenue and Silver Street around 1925.

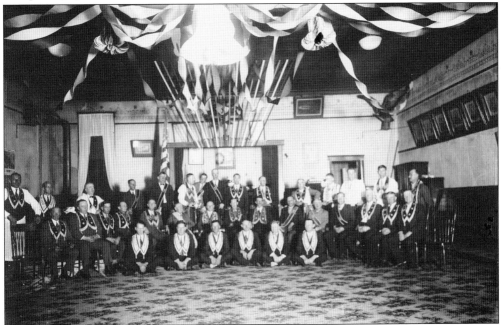

The Independent Order of Odd Fellows (IOOF) is a service organization that was imported from England in 1819. These 36 members of the Hailey chapter of Odd Fellows pose in full regalia in the IOOF building on the corner of Croy and Main Streets around 1935. Martyn Mallory is standing in the third row, second from the left. The hall is decorated for one of the many festive occasions, such as dances, that were often held there.

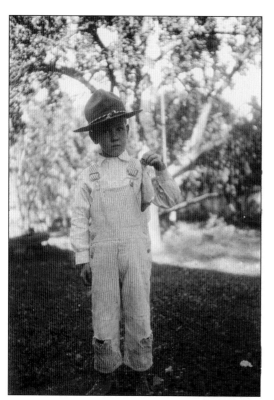

Young Bill Mallory, Martyn's youngest son, is pictured around 1930 with a fresh-caught fish. With a quality trout stream running through the middle of Hailey and the entire valley, anyone could put a line in the water just walking distance from home.

Barnum Mallory, Martyn's father and local Hailey businessman, pauses behind the S.J. Friedman store in downtown Hailey. The unique location of Hailey in the western mountain ranges make the winters very snowy while the high altitude and dry air make a snow-covered day still warm enough to be out without coat, scarf, or gloves.

Mable Mallory, Martyn's younger sister, looks aside as Martyn catches a photograph of her and two friends on a winter outing around 1900. The Watt Building is visible in the background, and the shadow of Martyn's bowler hat is captured on his sister's skirt.

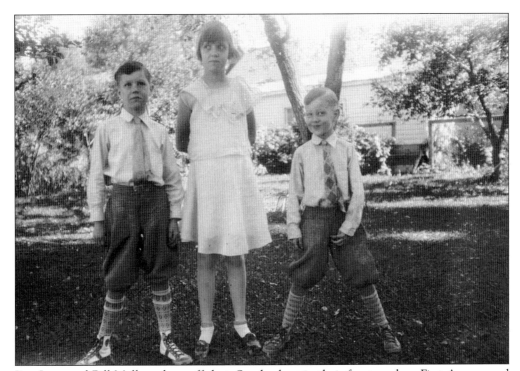

Jim, Jean, and Bill Mallory show off their Sunday best in their front yard on First Avenue and Silver Street in Hailey around 1930. Notable are the dapper socks and shoes to compliment the short pants.

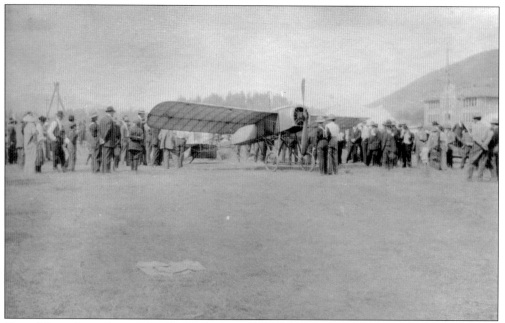

One of the early airplanes to land in Hailey came for the 1916 Blaine County Fair, held at that time in Werthheimer Park at the south end of Hailey. The Della School building, in the approximate location of the present-day Hailey Elementary School, is visible in the background on the right. (Courtesy of John and Joan Davies.)

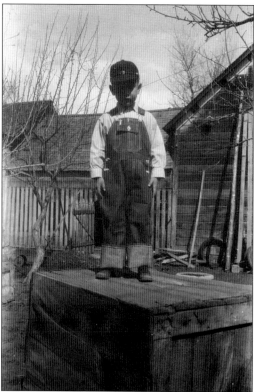

Young Bill Mallory poses on a crate in the Mallory family backyard. Clearly, young Bill can hardly contain his enthusiasm over his baggy new overalls.

A local Hailey businessman poses behind a building in late spring. At this time (about 1900), most photographs were taken outdoors to use the intensity of light provided by the sun to ensure good images.

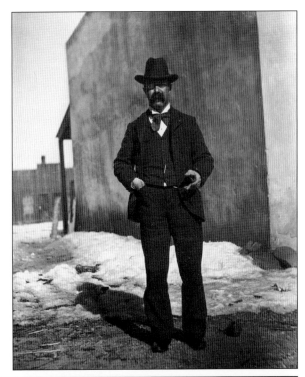

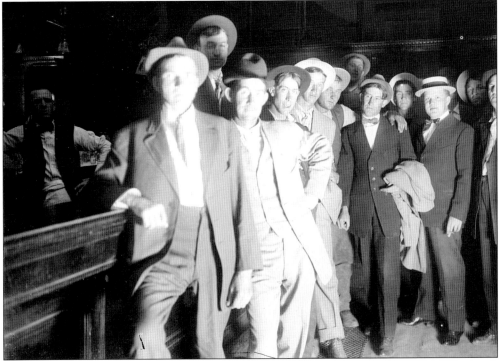

A group of men pose inside one of Hailey's several saloons around 1910. The ornate woodwork was a trademark of the fancier establishments. Martyn's early attempts at flash photography overexposed the men closest to the camera.

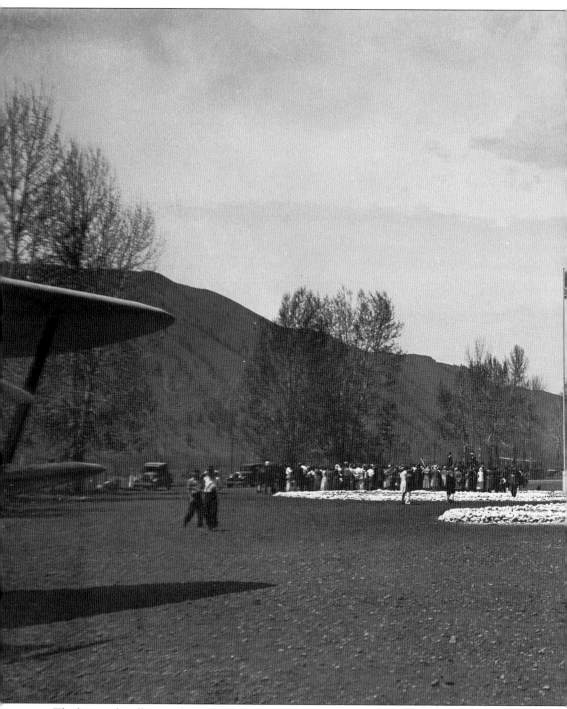

The banner headline in the May 19, 1932, *Hailey Times* read, "Hailey Honors Pioneers With The Most Beautiful Airport in Idaho." The article goes on to say, "The Wood River Valley passed an important point in her history Saturday [May 14, 1932] when the Friedman airport in Hailey was dedicated with fitting ceremonies with five airplanes present to add distinction to the affair."

The photograph shows the whitewashed rocks that spell the word *Hailey* on the right and those that are laid out in a compass around the flagpole on the left. The crowd is gathered around the speakers' platform, and the wing tip of one of the planes is visible on the left of the photograph. A snowcapped Bald Mountain is visible in the background.

According to the *Hailey Times* of May 19, 1932, "The airport was in perfect condition for the dedication thanks to the public spirit, the intelligent efforts, and the hard work of M.S. Benedict, the state highway department, the Boy Scouts and citizens who devoted time and labor to the clearing off of the rocks, the filling of the ditches, the removal of trees and the leveling of the field."

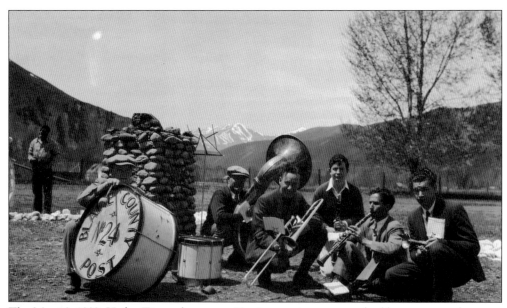

The May 19, 1932, *Hailey Times* also states, "An interesting program had been arranged to start at 11 o'clock with music by Johnny Bolliger's improvised band. . . . Another interesting feature of the field is a monument built of the native stone and a few rare specimens of native ores. On the north face is to be inserted a bronze tablet as a testimonial to S.M. Friedman whose family made possible the airport."

"A beautiful interlude was the raising of the handsome sparkling American flag by Miss Lucile and Leo Friedman assisted by Captain Benedict. As it arose the band played *The Star Spangled Banner* with all heads uncovered and former soldiers standing at attention. A great cheer went up as the flag fluttered out from the top of the pole," states the *Hailey Times* on May 19, 1932.

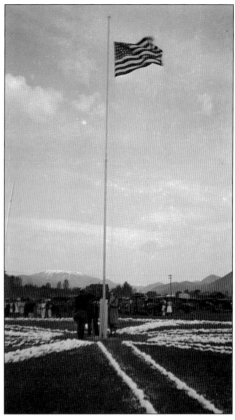

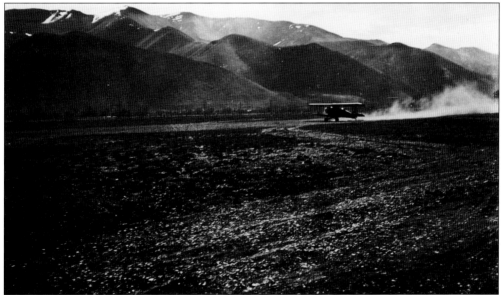

"It was the first time that more than one airplane was in the valley and the unexpected arrival of so many birdmen aroused the greatest enthusiasm. All made beautiful landings; all were enthusiastic in praise of the beautiful airport, and there was not the slightest mishap of any kind to mar the pleasure of the day," according to the May 19, 1932, *Hailey Times*.

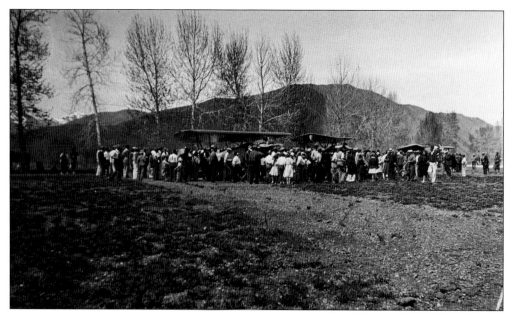

The *Hailey Times* of May 19, 1932, reports, "There she comes! . . . Sure enough keen eyes had caught the tiny speck high up in the heavens over Mount Della coming from the west. This knocked the program in the head as every eye was fixed on pilot A.A. Bennett of Boise as he circled around in his Wasp-Motored Zenith. When the plane came to a stand-still after a perfect landing the crowd made a rush to greet the first airman ever to land in Hailey."

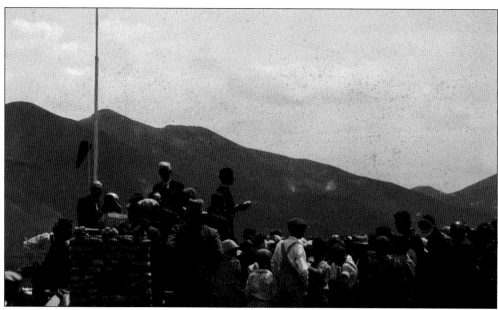

At the ceremony's close, the *Hailey Times* from May 19, 1932, states, "Miss Vera Romaine was loudly cheered for her fine reading from Walt Whitman's O, Pioneer. This was followed by the singing of *Here We Have Idaho* by the pupils of the Central School."

Four

RECREATION

Hailey's central location in the Wood River Valley, which was so important in Hailey's emergence as a major center for mining and transport of goods, also contributed to its popularity as a recreational center. Hailey's proximity to the Big Wood River and the Sawtooth Mountains allowed Hailey's residents to strike a sensible balance, as mentioned earlier, between work and play. Hailey residents have been known to "hike Carbonate," either before work or during their lunch breaks. Swimming or tubing on the Big Wood is a sure cure for a hot day in the summer. In days past before the coming of Sun Valley, Quigley Canyon was a popular destination for snowshoeing, what early residents called skiing. When Hailey's streets were clogged with snow and travel was suspended, folks brought out their dogsleds and raced them down Croy Street or even Main Street. Hailey has always been a four-season recreational paradise. With hiking, biking, fishing, swimming, camping, and hunting in the spring, summer, and fall, and skiing, sledding, and skating in the winter, Hailey residents have, from the town's earliest days, taken advantage of the wonderful natural resources that surround them.

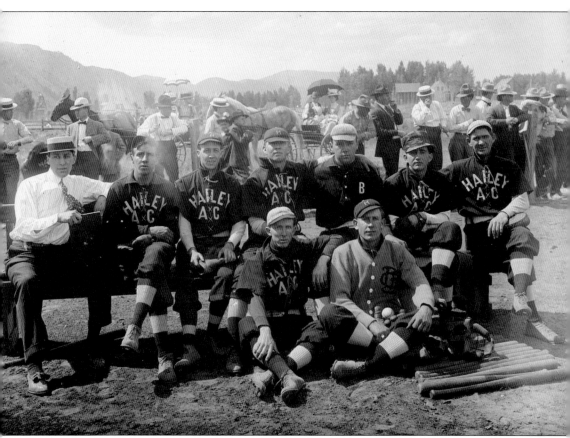

The brave men of Hailey banded together every Fourth of July to do battle on the baseball diamond at Werthheimer Park, typically with their mortal foes from Bellevue to the south. These games were one of the highlights of the annual celebration. This photograph shows the ball club on the day of the big game around 1910. The fellow on the bench in the white shirt and straw hat serving as manager is Leon Friedman, son of Simon M. Friedman, pioneer merchant. Martyn Mallory is third from the left on the bench. Notable is the enthusiastic crowd along the wire fence and the horses and buggies with ladies holding their parasols against the strong mountain sun. Della School (Hailey High School) is just visible along the right edge of the photograph.

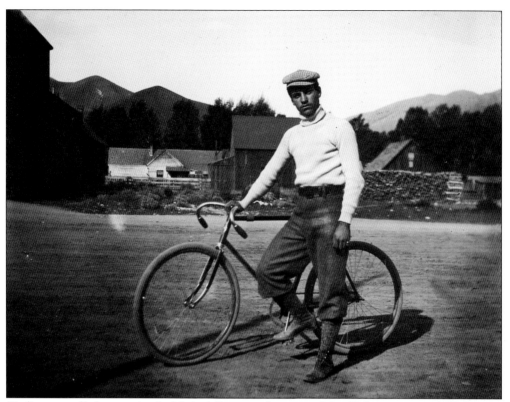

Cycling was all the rage in the United States at the turn of the 20th century, and Hailey was no exception. This well-dressed cyclist is posing on Main Street in Hailey in front of the field between the Commercial Building and the Watt Building (Christopher and Company) on the left of the photograph. Notable is the absence of brakes or a gearshift on his bike.

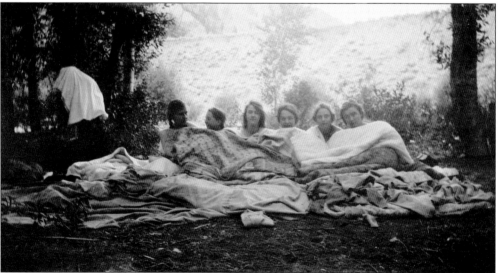

This group of teenage girls poses for an early-morning wake-up call. Air mattresses were probably yet to be invented, so they fashioned a makeshift bed out of layers of blankets. The extra blankets on top combined with proximity would keep them warm during a chilly mountain night.

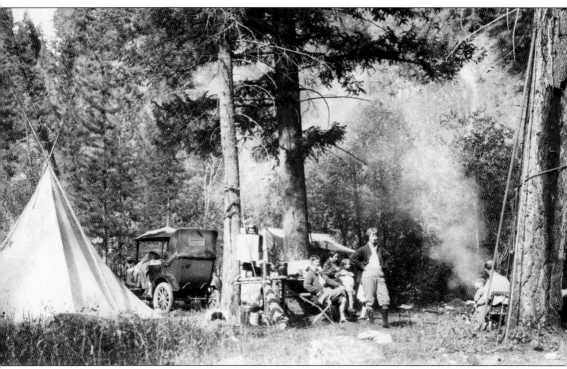

The Mallory family is enjoying mountain camping with their friends the Bolligers around 1920. Equipment used by these experienced car campers includes the long pole for collecting high deadwood for their campfires (leaning against the tree on the right), the teepee-style canvas tent tied up with fresh pine saplings, the striped hammock not yet deployed (leaning against the portable kitchen in the lower center of the photograph), and the abundant portable camp stools and chairs. From left to right in the photograph are Marie Bolliger, Elva Mallory (Martyn's wife), daughter Jean Mallory (getting a hair trim), Vera Jones (Marie's sister), Jim (Mallory's oldest son), and Martyn Mallory.

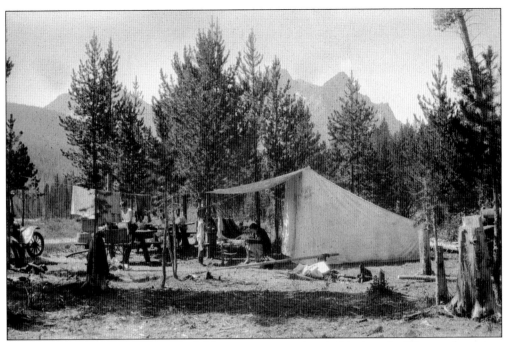

The majestic scenery of the Sawtooth Mountains was an irresistible draw for hikers and campers in the early days, as it is today. In another view of the Mallory's and Bolliger's campsite, the hammock mentioned in the previous picture has been deployed and is being used (center of the photograph below the tent awning) while Elva Mallory and John Bolliger relax and enjoy the mountain air.

This well-appointed campsite provides all the comforts of home, from the lantern-lighted kitchen area, to the tablecloth on the dining table, to the big box of breakfast corn flakes near the center of the photograph.

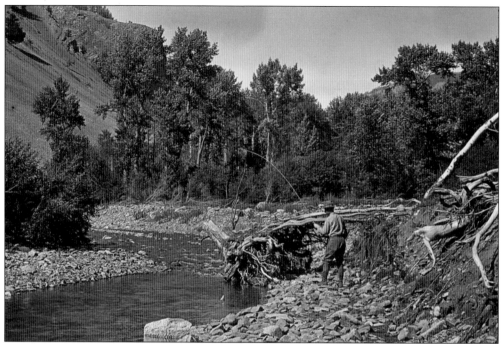

A fisherman has a nice trout bending his rod on the Big Wood River around 1920. An amazing resource going back to Hailey's earliest days, fishing the Big Wood has been a popular, productive, relaxing pastime.

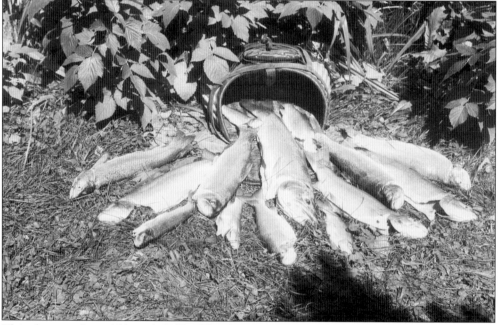

This photograph could be titled, "Big Wood River Bounty." The overflowing creel of speckled beauties pays tribute to the amazing productivity of the Big Wood River. Listed as one of the top 100 trout streams in the United States by the Trout Unlimited organization, this fishery has attracted locals and tourists for over 150 years.

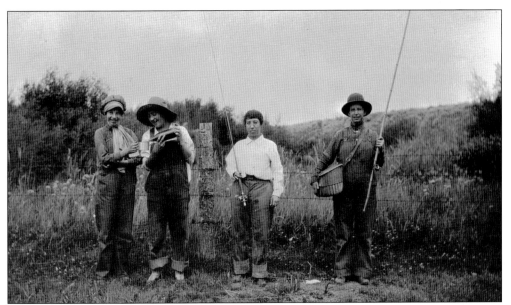

Proving once and for all that fishing in the Wood River Valley is not a male-only pastime, Nettie Mallory (third from left) and her pals get into the spirit of a day on the river around 1900.

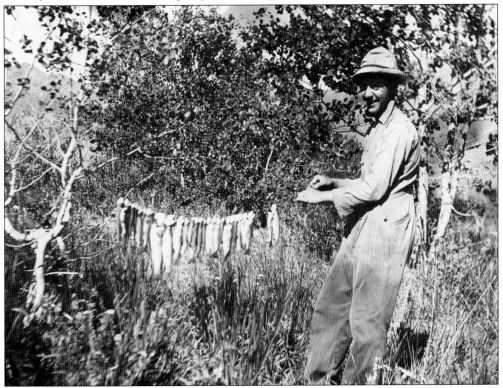

Taking two-dozen trout may appear a bit greedy by today's standards, but around 1900, fish probably provided a welcomed source of protein for families in the valley. By all accounts, collecting such a stringer was a mere few hours work. As shown by the wet overalls, fishing gear was not as elaborate (or expensive) as it is today.

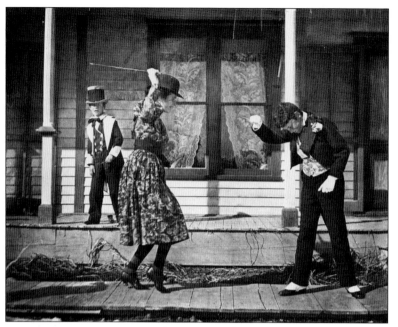

Hailey has always valued intellectual as well as physical pursuits. These young people are rehearsing for a play in elaborate costumes. Notable are the high front porch of the building behind as well as the wooden sidewalks, both necessary in a time when unpaved roads were either muddy or dusty, depending on the time of year.

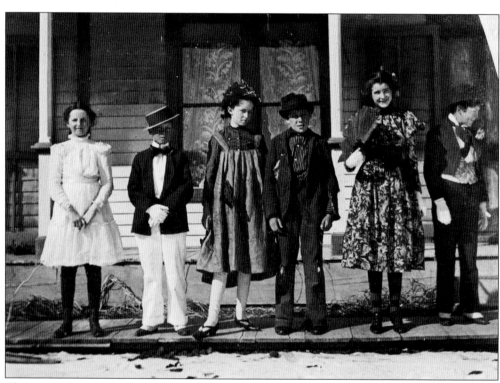

The ensemble poses for the photographer around 1900. Judging by the snow in the foreground, it appears the photograph was taken in April or early May, so the cast may be preparing for a school play rather than a neighborhood show. These 12–14 year olds would have attended classes in the Hailey Public School on the hill above Third Avenue between Silver and Galena Streets.

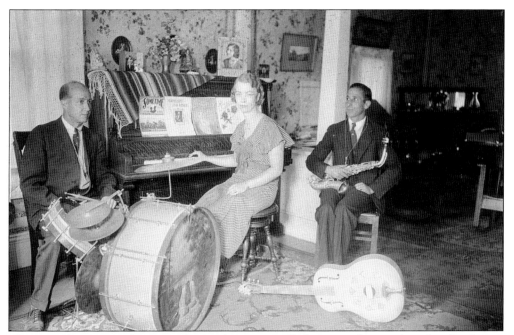

The Triangle Trio was the name of a popular amateur Hailey musical group that played at dances and other local functions. From left to right are Martyn Mallory on the drums, Vera Jones on piano, and John Bolliger on saxophone and guitar.

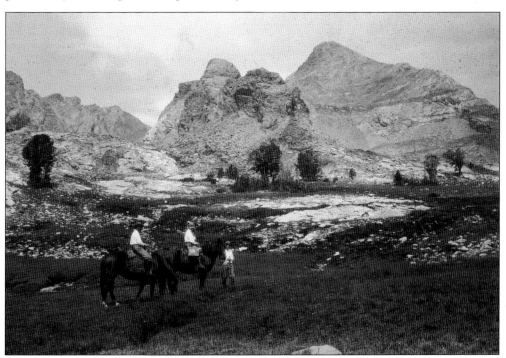

Hyndman Peak in the Pioneer Mountains provides a spectacular backdrop for this pair of horsewomen. On horseback, even some of the remotest mountain scenery was accessible to the average person. The Wood River Valley continues to support a flourishing "horse culture."

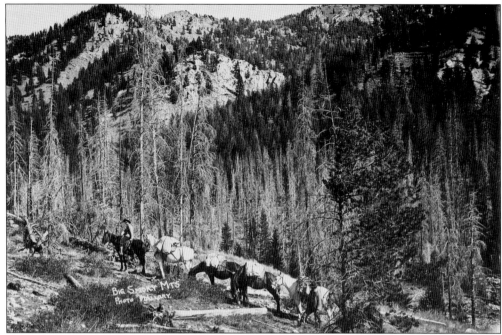

Horses were useful not only for recreational riding in the mountains, but also as pack animals. This hunting party was able to move essential gear and supplies high up in the Smoky Mountains through rough terrain because of their horses.

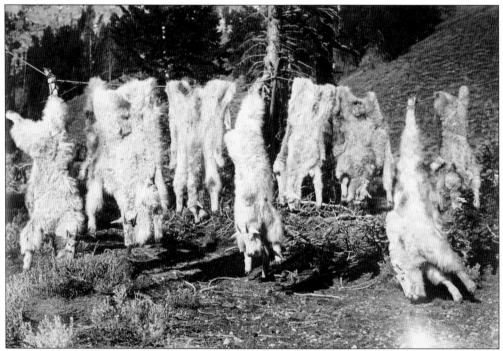

Although now rare, mountain goats were a popular big-game quarry in the mountains of central Idaho in the early days. In this photograph, the eight thick white skins of these animals indicate a very successful hunt.

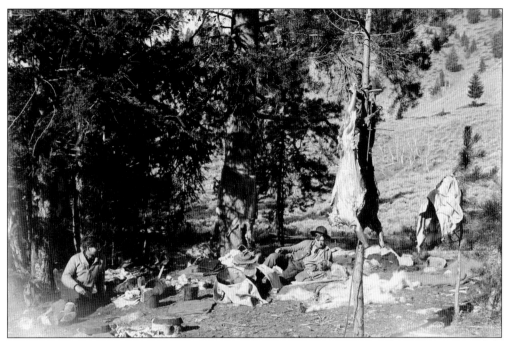

Following a successful day, two members of a hunting party lounge at their campsite. While the carcass of a freshly killed mountain goat hangs from a tree to dry, the skin is spread on the ground. On the large tree in the center of the photograph, another skin, possibly a deer, is stretched to dry.

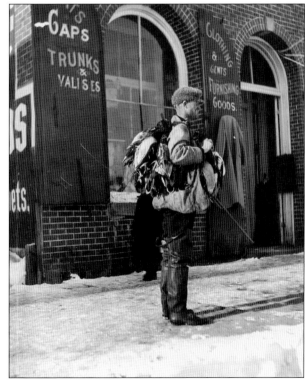

Weighed down with his quarry, a duck hunter pauses in front of S.J. Friedman's store in downtown Hailey. His rubber hip boots and heavy wool cap provided some protection from the chilly, late fall conditions he experienced in the nearby slough where he was hunting.

79

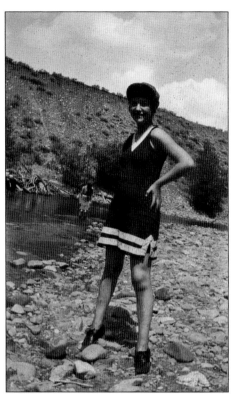

The height of fashion is displayed by a young woman in her 1920s-era bathing suit. The water level in the Big Wood River suggests the warm days of late July or early August when a dip in the chilly water provides some relief from the heat.

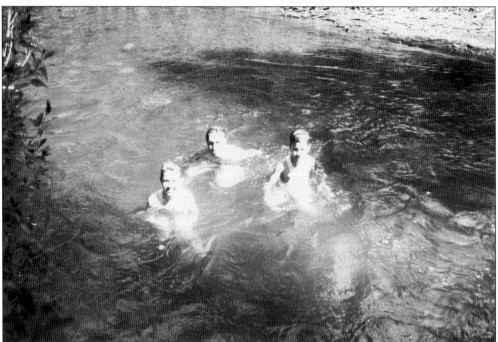

These boys enjoy a local "swimmin' hole" in the hot days of midsummer. The gin-clear waters of the Big Wood are an irresistible attraction when there is just nothing else better to do on a hot summer's afternoon.

These two young women cool their toes in the icy water of the Big Wood River. Given the river is no more than a quarter mile from the heart of downtown Hailey, these two could be on a break from their office or sales jobs and have found a means to soothe their sore feet in the middle of the day.

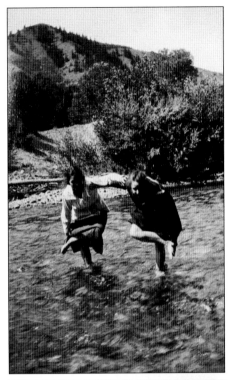

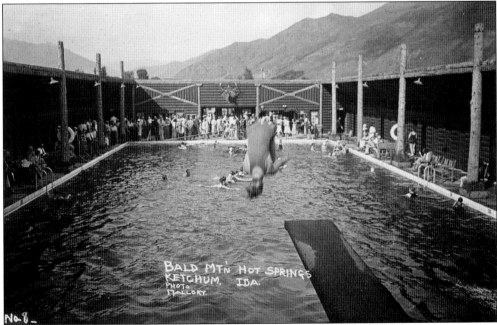

BALD MTN HOT SPRINGS
KETCHUM, IDA.
PHOTO
MALLORY.

No. 8

The Wood River Valley is blessed with numerous hot springs providing a supply of mineral-rich, soothing hot water. Several of these springs were diverted into pools for the enjoyment of bathers. The Bald Mountain Hot Springs Motel in Ketchum relied on hot water piped in from Warm Springs. The warm water of the "plunge" made the motel a popular venue during its heyday from the 1930s to the 1950s.

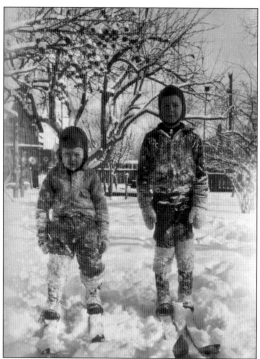

Well before Sun Valley brought high-class skiing to the Wood River Valley, local residents became proficient in snowshoeing, as skiing was called. In this late-1920s photograph, the two young Mallory boys have been practicing their "face plants" in the soft snow covering their backyard in Hailey.

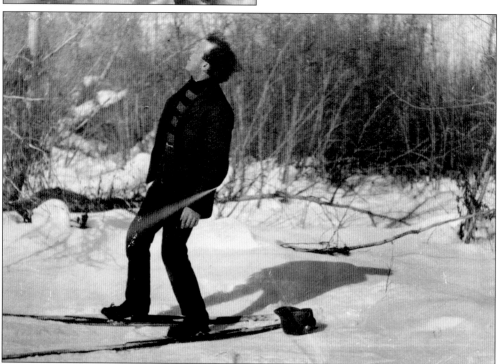

Around 1900, young Martyn Mallory shows off his cross-country skiing technique. His wind-swept hair and recently fallen hat suggest he is moving along at quite a clip at the time the camera froze the action. The white line running across his left sleeve is likely the string Martyn often used to snap the shutter for pictures he wished to be in.

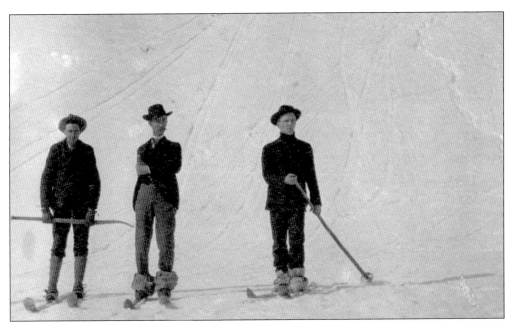

Several styles of snowshoeing are demonstrated in this late-1800s photograph. The fellow on the left holds a pole with a curved end designed to be dragged behind for turning and speed control. The gent in the center uses the "devil may care" freestyle approach, and the skier on the right demonstrates the pole-dragging technique most commonly used in this era. Also notable are the various precursors to ski boots.

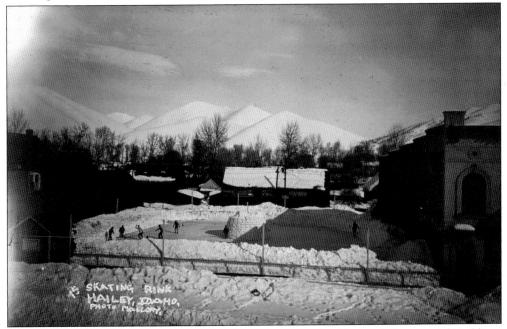

The lots left open by the 1889 fire on Main Street between the Watt and Commercial Buildings were put to good use during the winter months. Townspeople created a public skating rink in the heart of downtown Hailey with a large snow igloo at the center of the rink and a warming house on the left.

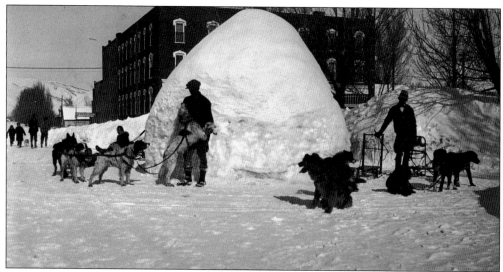

A popular winter activity was dogsled racing through the snowy streets of downtown. In this photograph, several mushers are preparing their dogs for an upcoming race. The "snowstack" in the center of the photograph is in front of the courthouse on First Avenue. The Hiawatha Hotel is visible in the background.

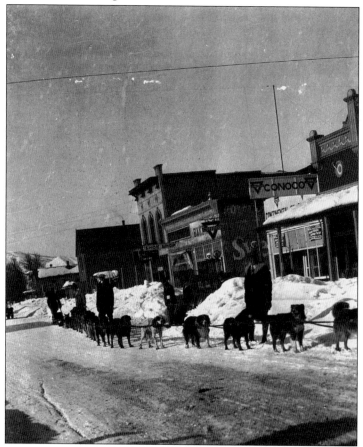

These fellows might be vying for the record for the most "mutts" harnessed to a dogsled at one time. As can be seen from this photograph, huskies were uncommon in Hailey dogsled racing. The 1920s photograph was taken in front of the Harris Furniture Store on Main Street near the intersection with Bullion Street.

Five

AMATEUR PHOTOGRAPHER MARTYN MALLORY (1880–1936)

Although he was an extraordinary individual, in many ways Martyn Mallory displayed the typical Hailey "pluck and energy" that allowed the town to survive and flourish through the several "boom and bust" cycles of its history. Born in Utah in 1880, Martyn moved in 1883 with his parents to Hailey, where he would spend the rest of his life. Martyn was fascinated both with the budding art of photography as well as the remarkable sights of the Wood River Valley and surrounding countryside. Whether climbing Carbonate Mountain, lugging his bulky box camera and glass-plate negatives for a panoramic photograph of the city, clowning with his friends, or packing into the local mountains to collect images of the lakes, streams, and peaks, Martyn tirelessly pursued perfection in his photographs. Although he was never a full-time professional photographer, Martyn's images are truly remarkable. For nearly 40 years, Martyn roamed the streets of Hailey as well as the hills and mountains of the surrounding countryside with his camera. Martyn was also a family man and proud father. Included in the photographic collection are the types of photographs of his family that are familiar to everyone.

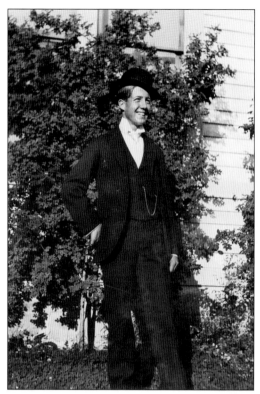

Martyn was already experimenting with photography by the time he was a teenager. In this photograph, probably taken around 1896, Martyn poses in a fancy suit and hat outside the family home in Hailey. Martyn often used a string tied to the shutter to include himself in the photographs.

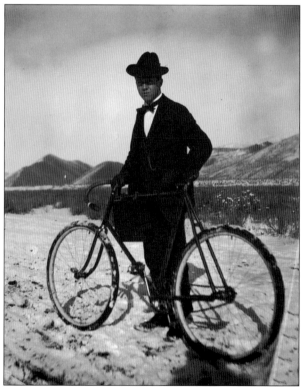

Martyn stands with his bicycle following an early fall snowstorm around 1895. Riding a bike through snowy streets is not uncommon in Hailey even today.

These portraits of Martyn and Elva Bernice Obenchain were probably taken shortly after their marriage on March 2, 1919, in Hailey.

Martyn's sisters Marietta Ann (Nettie) and Mabel Sarah Mallory pose with their garden flowers outside the family home in Hailey around 1900.

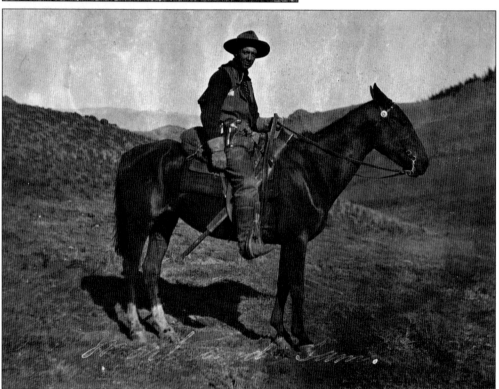

This photograph labeled "Mart and Sam" shows Martyn in full cowboy regalia mounted on his favorite horse, Sam. Armed with a rifle in the scabbard and a pistol on his belt, Martyn is clearly "ready for action."

Sarah Columbia Pierce Mallory and Barnum Meredith Mallory, Martyn's parents, were born in New York but met and married in Kelton, Utah, in 1873. They moved from Utah to Hailey in 1883 where they spent the remainder of their lives. Sarah died in Hailey in 1915, as did Barnum in 1933.

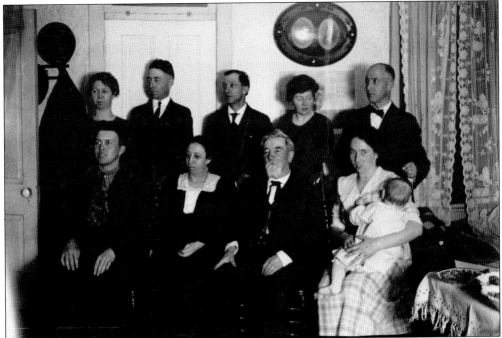

The Mallory family poses for a formal indoors shot in 1920. From left to right are (first row) Meredith Mallory (Barnum Jr.'s son, raised by Barnum and Sarah, his grandparents), Nettie, Barnum Sr., and Elva, holding baby Jean (born in December 1919); (second row) Mabel, husband William Hailey Horne (Hail), Charles Mallory (Martyn's younger brother), Sadie May Young Mallory (Charles's wife), and Martyn (pulling the string held in his left hand to take the photograph).

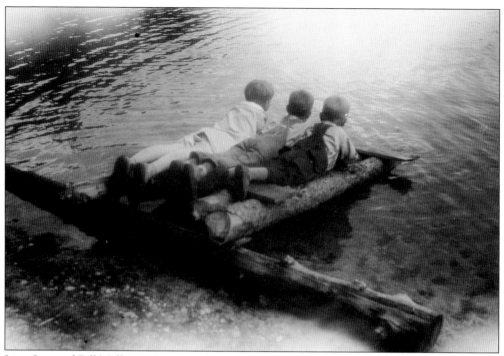

Jean, Jim, and Bill Mallory, Martyn and Elva's children, lie on a log raft peering intently into the water on the edge of a mountain lake, probably Redfish, around 1929.

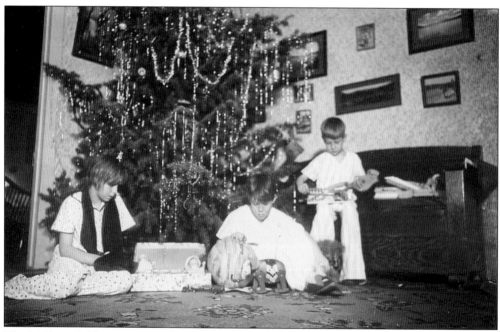

The Mallory children are captured opening presents at their home on First Avenue in Hailey on Christmas morning around 1930.

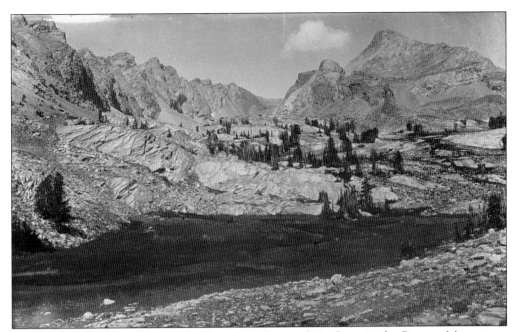

Hyndman Peak is a well-known landmark northeast of Ketchum in the Pioneer Mountains. Martyn's horse Sam can be seen in the photograph above grazing in the dark meadow grass, slightly to the right and below center of the photograph.

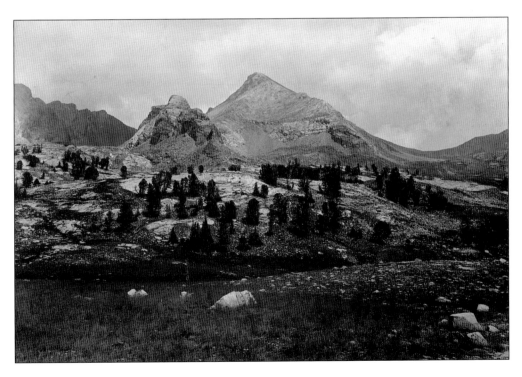

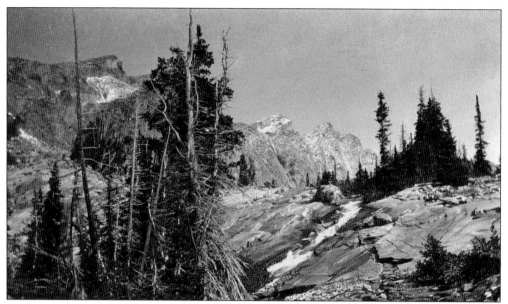

Martyn was captivated, like most people, by the majestic mountain peaks just to the north of Hailey. This photograph shows Duncan Ridge, near Hyndman Peak. Hyndman Peak sits at 12,009 feet, the tallest peak in the Pioneer range and the ninth tallest in Idaho.

The Boulder Mountains are a massive, high, rugged mountain range in the very heart of Idaho. The range stretches from Ketchum in the south nearly to Challis in the north. Highway 75 and the East Fork of the Salmon River form its western border while the Big Lost River Valley and the Pioneer Mountains are to the east and south.

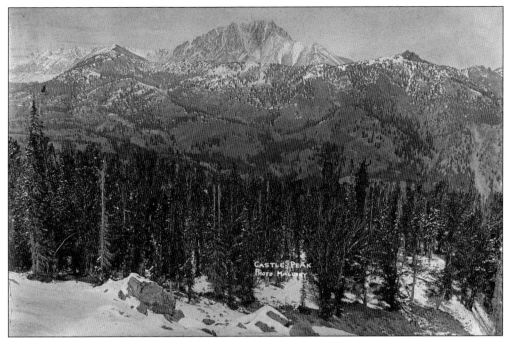

Castle Peak is a striking peak that dominates the White Cloud Mountains. The White Clouds sit across from the Sawtooths in between Ketchum and Stanley.

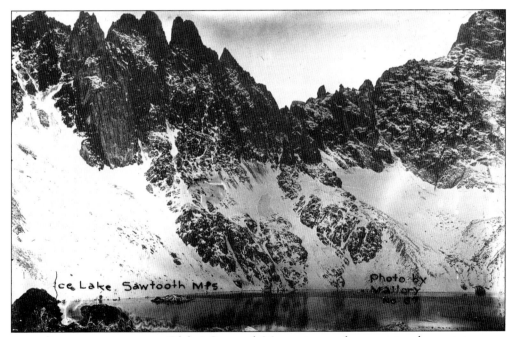

According to summitpost.org, "Idaho's Sawtooth Mountains are the crown-jewel mountain range of the state and the home of Idaho mountaineering and big-wall climbing. In a treasure trove of rock climbs, couloir climbs, and exposed scrambles, the region still retains a pristine, uncrowded nature despite its growing popularity."

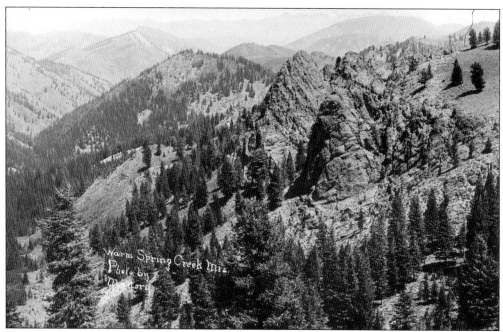

The Warm Spring Creek Mountains are located north of Challis and Stanley. The topography in the area is extremely rugged with elevations ranging from over 10,000 feet at Twin Peaks to 3,500 feet along the Middle Fork of the Salmon River.

Summitpost.org notes that "the Sawtooth Mountains contain 147 named or recognized peaks and towers in an area roughly 30 miles from north to south by 15 miles from east to west. In the Sawtooths, 33 peaks rise above 10,000 feet, and 116 have no identification. Some of these have never been climbed, and most have absolutely no known information or first-ascent data."

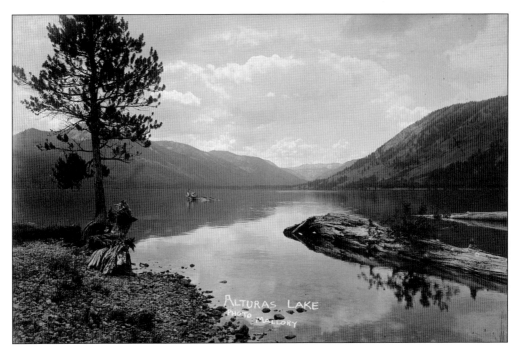

Alturas Lake is located in the Sawtooth National Recreation Area and is the perfect place to enjoy either summer or winter activities. Alturas Lake is 37 miles north of Ketchum or 25 miles south of Stanley. Locals and tourists alike are drawn back to the pristine setting of this scenic lake, which sits with a backdrop of the Sawtooth Mountains above and behind it. Alturas Lake is an excellent base for exploration of the Sawtooth National Recreation Area.

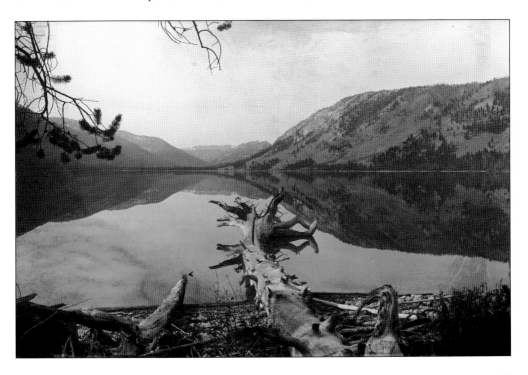

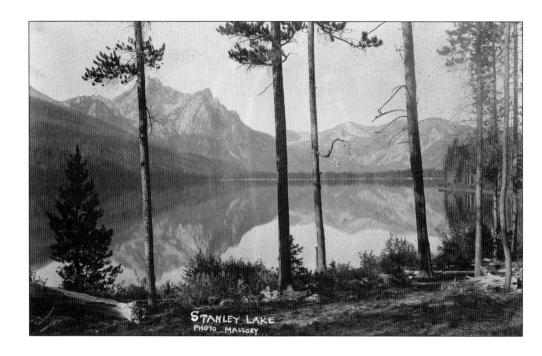

Stanley Lake is an alpine lake in Custer County located in the Sawtooth National Recreation Area. The lake is approximately seven miles west of Stanley, readily accessed via a three-mile spur road from State Highway 21. The surface elevation of the lake is 6,513 feet above sea level.

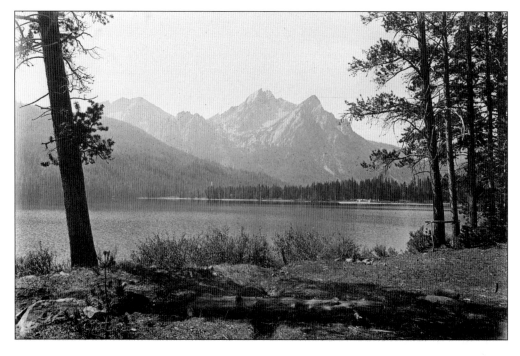

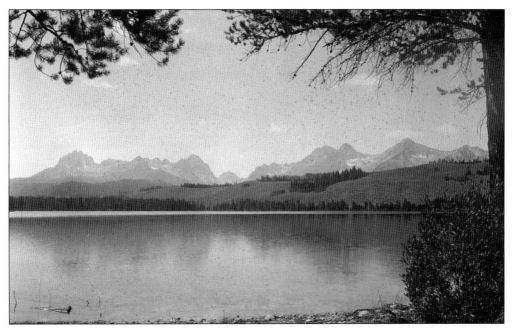

Redfish Lake is an alpine lake located in the Sawtooth National Recreation Area at the base of the Sawtooth Mountains in Custer County. It is named for the brilliant sockeye salmon that once returned from the Pacific Ocean in such massive quantities that the lake shimmered red during spawning season.

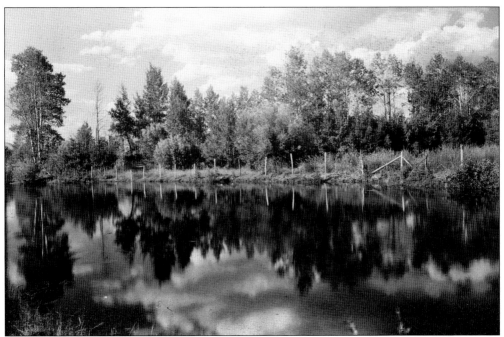

Martyn captured mirror-like reflections in this calm stretch of water. A single ripple, possibly from a rising trout, disturbs the otherwise unmarred surface on the left side of the photograph.

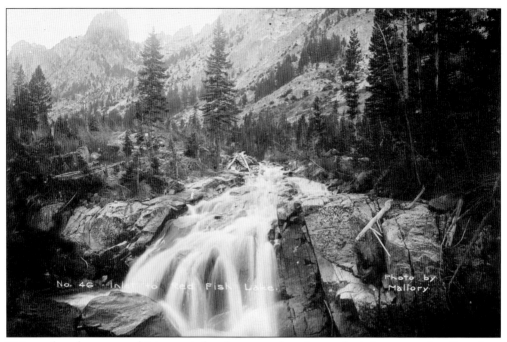

Using a slow shutter speed, Martyn imbued a sense of motion to the inlet stream that flows into Redfish Lake, forming a delightful waterfall. The surrounding trees and peaks create a beautiful frame for the picture.

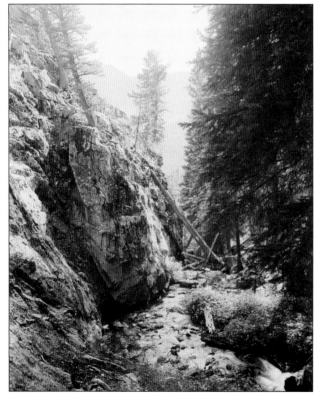

Martyn captured this spectacular scene that combines sheer rock walls, craggy pines, and one of the thousands of mountain streams that feed into southern Idaho rivers.

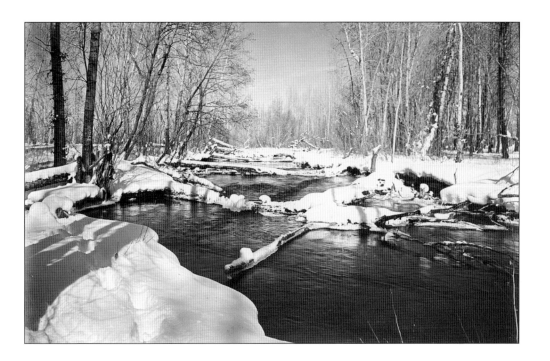

These images show two winter scenes photographed in the Wood River Valley. The picture above shows a stream with snowy banks and snags, possibly the Big Wood River, taken in late afternoon, as evidenced by the long shadows of the trees on the left of the photograph. Taken in Hailey, the photograph below shows Della Mountain nicely framed by two snow-covered evergreen trees.

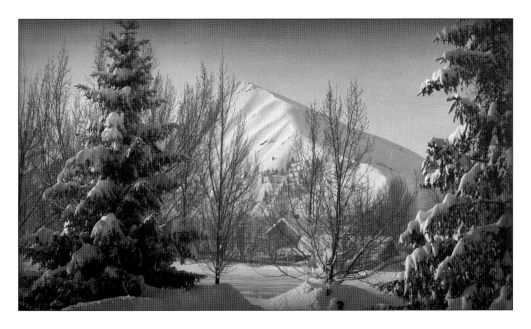

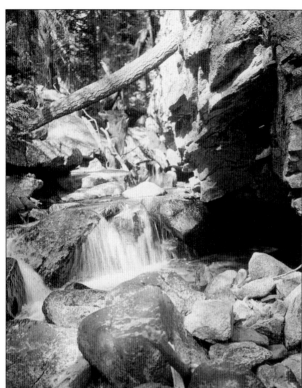

The inlet stream to Redfish Lake makes lovely cascades and pools as it tumbles over the rocks on its way to the lake.

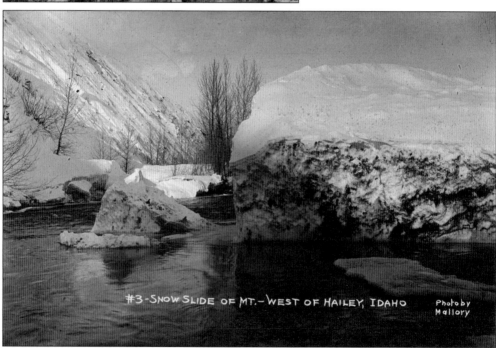

#3-SNOW SLIDE OF MT.—WEST OF HAILEY, IDAHO Photo by Mallory

This major snowslide temporarily blocked the flow of the Big Wood River west of Hailey. Such events that occur later in the spring when the flow rates are higher can now result in serious flooding in neighborhoods near the river that were fields in Martyn's day.

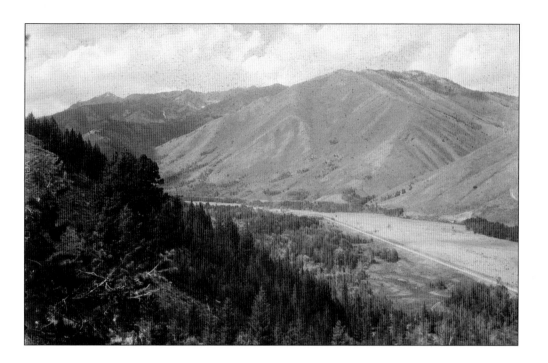

In these two views of the Wood River Valley, both taken from the west side of the valley looking north, Martyn used two different perspectives to create two very different effects. In the photograph above, the foothills in the background provide the major focus of the composition while in the picture below, the emphasis is on the steep valley wall and tree in the foreground.

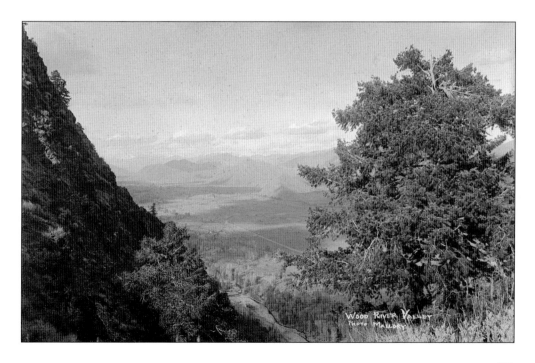

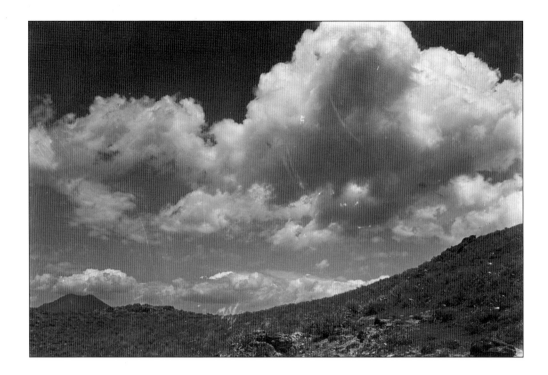

Martyn was very interested in the infinite shapes and textures of cloud formations. In the above photograph, the bases of the clouds seem to mimic the slope of the distant hills. Martyn also used exposure to emphasize the contrast between the light-colored clouds and the dark landscape. In the photograph below, Martyn used a double exposure to fill the frame with dramatic cloud formations. Looking closely at the billowy clouds in the center of the photograph reveals a second landscape cleverly blending in behind the clouds.

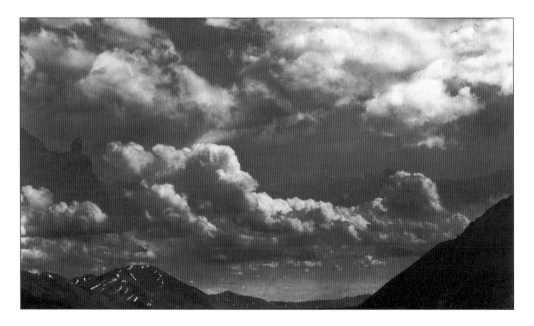

Six

FOURTH OF JULY

The Fourth of July has been an important celebration in Hailey since its earliest days. Although the parade has traditionally been a major focus for the celebration, in the past there were horseraces and footraces, baseball games, speeches from fiery orators, carnivals, and in the last 50 years, a first-class rodeo. It was a remarkable accomplishment that a town of less than 2,000 consistently put together such a grand celebration year after year.

What follows are several excerpts from an essay written by Harold C. Mandell, who was a boy in Hailey at the turn of the 20th century. They are provided courtesy of the Blaine County Historical Museum.

In our town when I was a boy we didn't just "observe" the Fourth of July. We celebrated it and for three days. Hailey threw itself into its three day Fourth of July celebration with great enthusiasm. Planning and preparation began weeks before. While school was still going on we commenced to earn and save money for The Fourth. We sat and discussed amongst ourselves everything that was done to get ready for the day.

You knew that The Fourth was not far off when you heard the boom of the bass drum as the village band commenced to practice playing and marching in the streets at evening and you usually rushed to the scene and joined an excitedly prancing crowd around the band.

People gathered from far and near, from the Stanley Basin three days distant by horse drawn conveyance, from Camas Prairie, from Little Wood River, and from Silver Creek. Families came from lonely ranches. Prospectors left their cabins in the mountains and the gulches and came to Hailey for the Fourth of July. For many this was the only visit to town during the year. By the evening of the third the population was vastly increased. People camped down by the river. Hotels and rooming houses bulged. Livery stables and feedlots were filled with horses and vehicles.

As we watched and exchanged information about these wonderful goings on excitement increased almost to the bursting point.

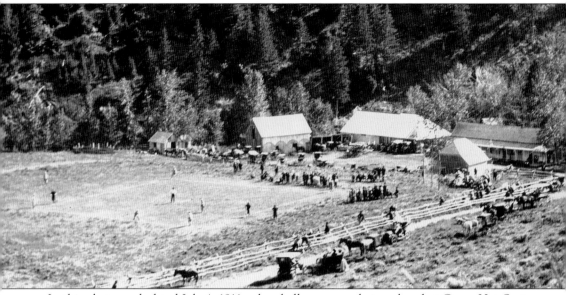

In this photograph dated July 4, 1911, a baseball game was being played at Guyer Hot Springs Resort (west of Ketchum on Warm Springs Road). Traditionally, the annual Fourth of July games were played at a field inside the racetrack at Werthheimer Park in south Hailey.

This advertisement appeared in the July 4, 1935, *Hailey Times* newspaper. The schedule included a full day of activities, many of which were held on the grassy lawn south of the courthouse where the Hope Garden is located today.

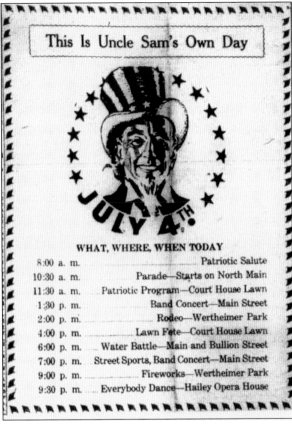

This Is Uncle Sam's Own Day

JULY 4TH.

WHAT, WHERE, WHEN TODAY

8:00 a. m.	Patriotic Salute
10:30 a. m.	Parade—Starts on North Main
11:30 a. m.	Patriotic Program—Court House Lawn
1:30 p. m.	Band Concert—Main Street
2:00 p. m.	Rodeo—Wertheimer Park
4:00 p. m.	Lawn Fete—Court House Lawn
6:00 p. m.	Water Battle—Main and Bullion Street
7:00 p. m.	Street Sports, Band Concert—Main Street
9:00 p. m.	Fireworks—Wertheimer Park
9:30 p. m.	Everybody Dance—Hailey Opera House

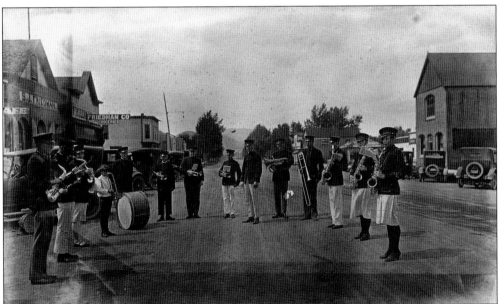

Hailey's volunteer Fourth of July city band is shown around 1910. The Friedmans' stores are visible on the left, and the Watt Building is on the right of the photograph. Perhaps the young trombone player on the left was too small to fit into one of the handsome uniforms.

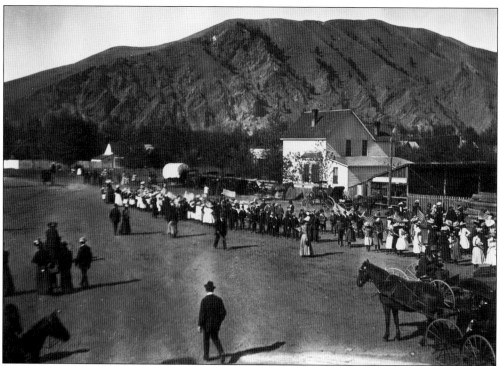

A large number of children can be seen assembled near Main Street in a staging area preparing for the Fourth of July parade in the early 1900s.

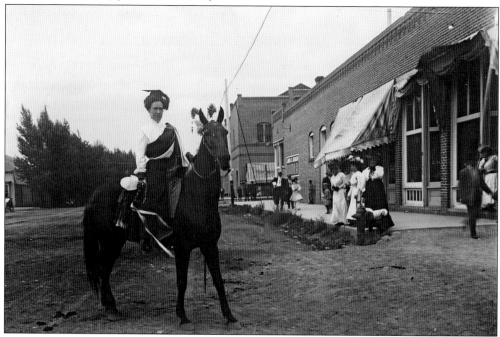

A woman on horseback with mortarboard hat, sash, and cape, perhaps a member of a women's fraternal organization or one of the "Citizens on Horseback" (a fixture of early parades), prepares to participate in a Fourth of July parade in the early 1900s.

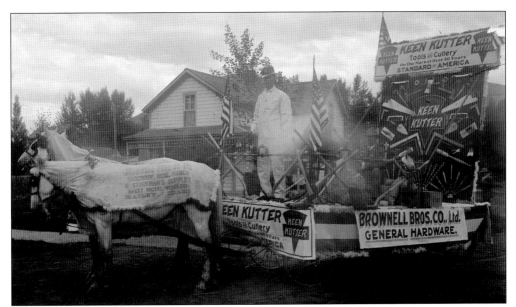

The Brownell Brothers Hardware Store float was covered from top to bottom with samples of their merchandise. Even the team of horses pulling the float helped with advertising this merchant's wares with their canvas covers promoting the hardware, mine, ranch, and stockman's supplies. In the photograph below, *RNA* stands for "Royal Neighbors of America." The society was formed, according to the early Royal Neighbors charter, "to bring joy and comfort into many homes that might otherwise today be dark and cheerless . . . by affording the mother an opportunity to provide protection upon her life." The RNA was one of several women's organizations formed during the 1800s to provide financial assistance to widows and children. In addition to the RNA, Hailey had chapters of the Degree of Honor and the Ladies of the Maccabees that entered floats in the early parades.

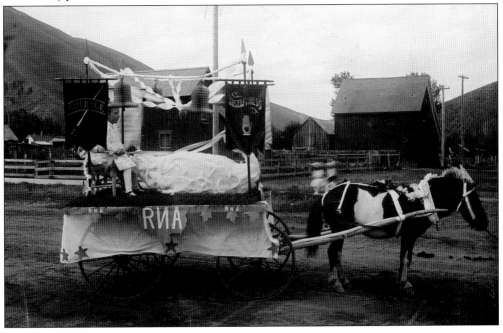

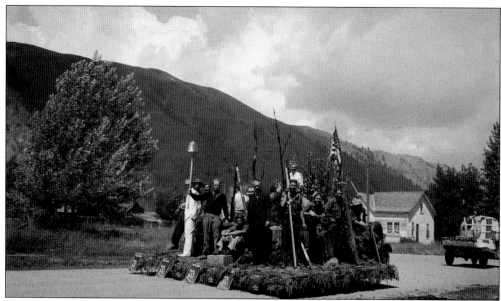

This float celebrating Forest Service firefighters is caught by Martyn's camera as the parade winds up First Avenue around the early 1930s.

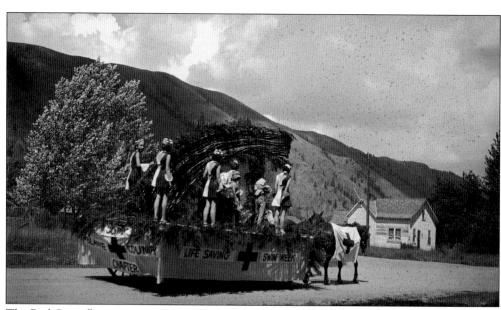

The Red Cross float promotes Swim Week with lessons held at the Hiawatha Hotel Natatorium around the early 1930s.

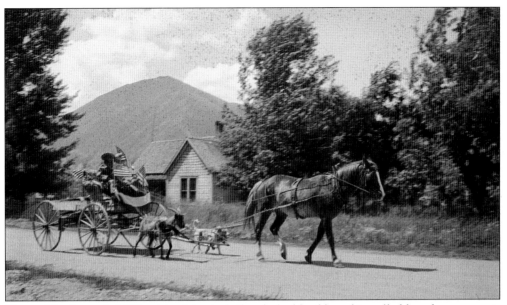

Pictured in the early 1930s, this whimsical, flag-decked buckboard is pulled by a horse, a goat, and a dog.

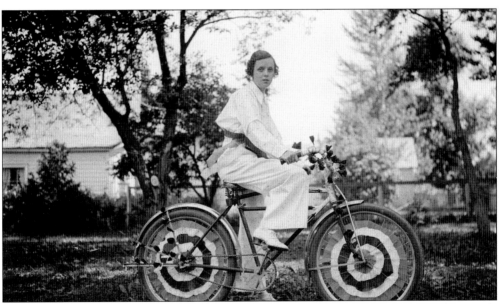

Martyn's eldest daughter, Jean, is displaying her well-decorated bicycle before the parade around 1932.

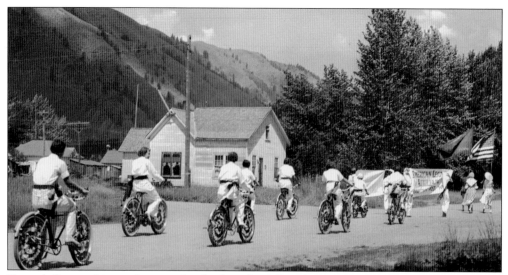

Young ladies in white uniforms and sashes bicycle on First Avenue as part of the American Legion Auxiliary entry in the parade around 1932.

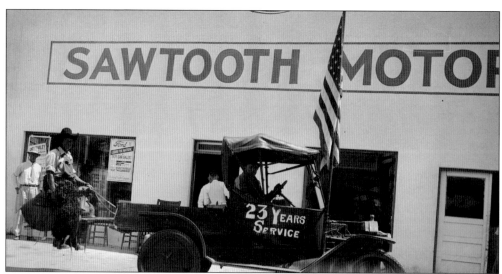

Sawtooth Motors provided an entertaining parade entry in 1935. The offset rear wheels would create a bucking motion for the cowboy on the pole sticking out the back of the truck.

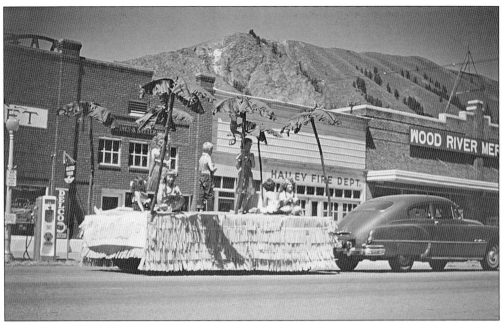

A group of children in appropriate dress evokes images of the islands in this "Aloha" float in 1953. The photograph was taken on Main Street between Bullion and Carbonate Streets. Notable are the Chevrolet dealer, fire department, and Wood River Mercantile on the west side of Main Street before Paul's Supermarket was built on this site and the present Bullion Square that followed the supermarket in 2004. Carbonate Mountain is visible in the background. In the photograph below, also from the 1953 parade, three young ladies grace the entry from Standard Garage. (Courtesy of Ralph Harris.)

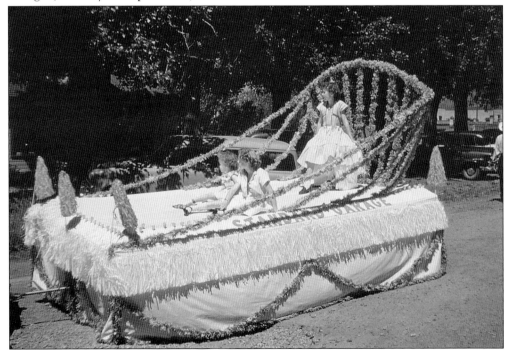

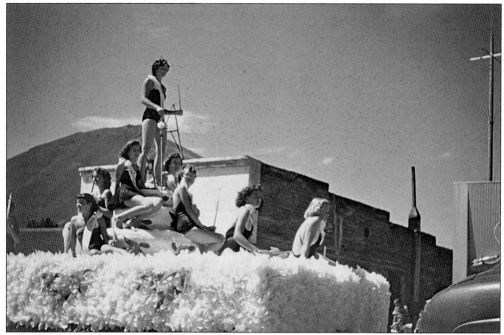

A group of lovely young ladies adorns this 1953 float entry. During the time when there was no Internet, cable television, cell phones, or instant access to outside news or entertainment, the residents of Hailey became adept at creating their own entertainment. The Fourth of July became a multiday festival that invited participation by the entire community and neighboring communities as well. (Courtesy of Ralph Harris.)

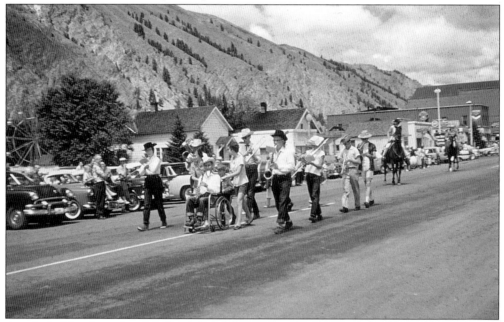

A makeshift band marches and plays on south Main Street as it passes by the forest service buildings in the 1958 parade. A Ferris wheel reveals the location of a carnival in the forest service complex that provided additional excitement for the holiday festivities. (Courtesy of Ralph Harris.)

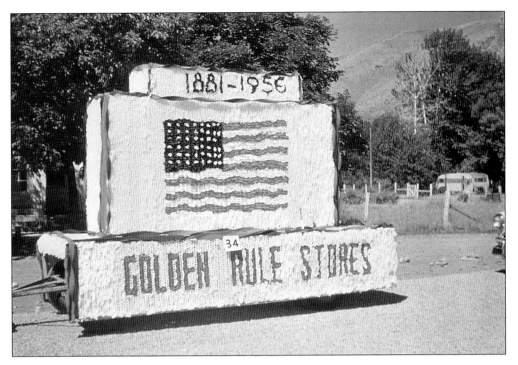

The 1956 Fourth of July celebration took on a special significance. That year, Hailey celebrated its 75th anniversary. This pair of floats, sponsored by the Golden Rule Store and the Rialto Hotel, represented the pride the community felt for not only surviving, but thriving since its founding in 1881. (Courtesy of Ralph Harris.)

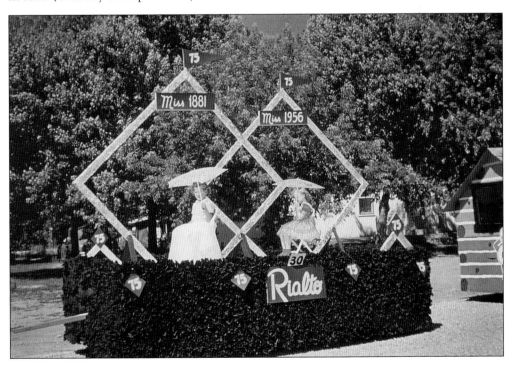

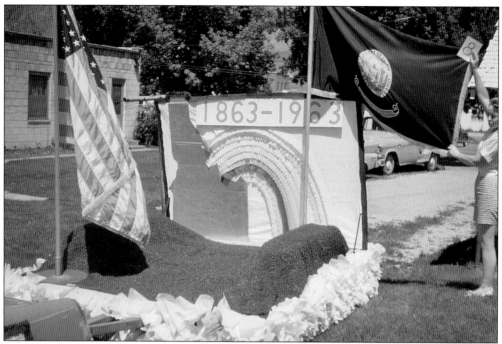

This float commemorates the 100-year anniversary of the formation of the Idaho Territory. Abraham Lincoln took time out from the Civil War to sign into law an act of Congress creating the Idaho Territory. The territory contained what are now the states of Idaho, Montana, and most of Wyoming with the first capital in Lewiston, Idaho. In 1864, the capital was moved to Boise. (Courtesy of Ralph Harris.)

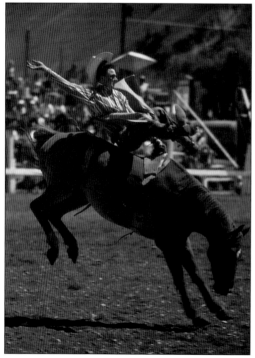

In 1949, the Sawtooth Rangers began hosting a rodeo in Hailey as part of the Fourth of July celebration. Construction on the original stadium, located in Werthheimer Park on the south edge of town, was begun in September 1948. This mostly wooden structure was demolished in 2011 to make way for the present Hailey Rodeo Park arena. The photograph shows a bareback bronc rider from the 1973 Days of the Old West rodeo in Hailey. (Courtesy of Ralph Harris.)

Seven

CHURCHES AND SCHOOLS

In July 1883, the first church building constructed in Hailey was St. Charles Catholic Church. In 1913, the present St. Charles Church was constructed at the northwest corner of First Avenue and Pine Street. St. Charles was the first parish established east of Boise and is considered the mother parish of southeastern Idaho.

Bishop Daniel Sylvester Tuttle (Episcopal bishop to Idaho, Montana, and Utah from 1866 to 1886) acquired the lots on the southwest corner of Bullion Street and Second Avenue for a church building and appointed the Reverend Israel T. Osborn (formerly of St. Michael's Episcopal Church in Boise) to the Wood River district. TAG Historical Research and Consulting noted, "Fundraising activities for the Episcopal church building were coordinated by Reverend Osborn's wife, Sarah, and the women of the congregation. The women held a variety of successful events, including fairs, bazaars, concerts, and masquerade parties and raised sufficient monies to start construction in the summer of 1885. Enough money was raised to pay for the church and a 500-pound bell." The first services in the almost completed church building were held on Christmas day 1885.

According to the *Wood River Times*, public school opened in a two-room schoolhouse in January 1882. A single teacher took charge of 21 boys and 15 girls. A year later, the attendance had risen to 90 with two teachers. To supplement insufficient tax support, the women of the community continually planned and carried out a wide variety of fundraising events. They purchased special supplies, including a 10-stop Estey organ (from Brattleboro, Vermont), maple and ash seats and desks (from Council Bluffs, Iowa), a piano, a chandelier, and a set of maps on which the infant mining town of Hailey appeared.

For Wood River or Bust explained, "As in other mining booms, when the mines and their communities had established themselves, sporadic services by itinerant preachers gave way to more regular religious observances in established church structures ministered by resident clergy." At the same time, schools, often elaborate structures built of bricks and mortar, were planned and built and teachers hired. "In the process, the fundraising activities of both youth and women's groups gave an additional and important dimension to cultural and recreational life."

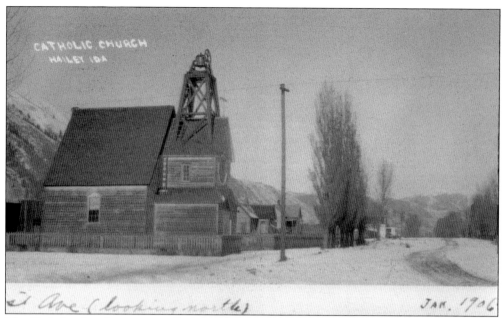

The Catholic church was originally located on First Avenue where Atkinsons' is situated today. By 1906, the building was moved to the lot adjoining the corner of First Avenue and Pine Street near where the present church is located today. The large circular window from this church can still be seen in the Reinheimer Barn along Highway 75 south of Ketchum. (Courtesy of the Blaine County Historical Museum.)

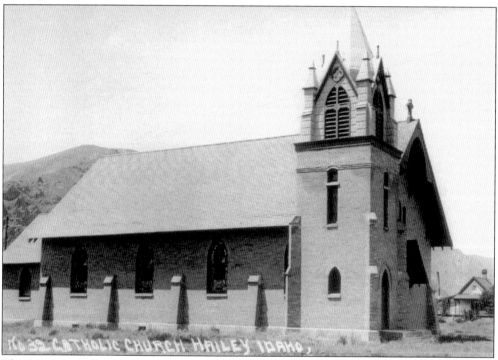

The "new" Catholic church constructed in 1913 can be seen at the intersection of First Avenue and Pine Streets. (Courtesy of the Blaine County Historical Museum.)

Built in 1885, Emmanuel Episcopal
Church is the oldest church building
in Hailey and the oldest church still in
use in the Episcopal Diocese of Idaho.
Emmanuel Episcopal Church is an
example of a modest Gothic Revival
parish church. Similar rural churches were
constructed from plan books available
to builders during the 19th century.
In the photograph below, parishioners
gathered in front of the Episcopal church
during the winter around 1930. A team
of horses, probably pulling a sleigh, waits
by the corner. (Right, courtesy of the
Blaine County Historical Museum.)

Dec 1907

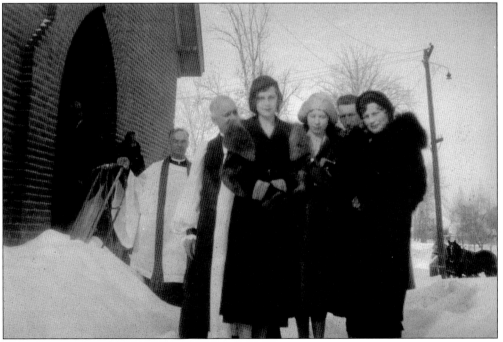

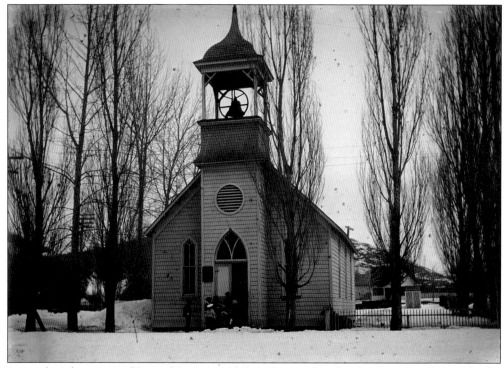

Located on the corner of Second Avenue and Croy Streets, the church was originally built by the Methodists in 1886. The church was acquired by the Baptists in 1929. Frances Julia Helman, wife of Methodist reverend C.E. Helman, wrote in 1885, "Businessmen, who never think of going into a church, pay $2 a month for each of the three preachers in town. The women have to do all of the collecting of the salary and do everything about the church business."

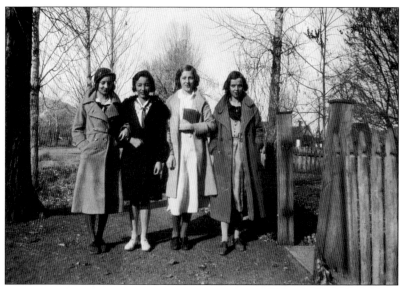

Jean Mallory (on the right) and friends walk to school, possibly their first day of high school around 1932. The photograph was taken from in front of the Mallory home on First Avenue.

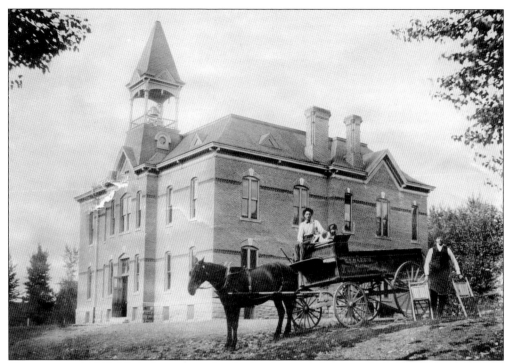

Shown around 1900, Hailey's two-story brick school provided a symbol of education and culture, much as an opera house did in other mining centers. It stood on a rise of "the bench" where it could be clearly seen with its 764-pound, 33-inch-diameter bell hanging in the belfry above eight large classrooms. (Courtesy of the Blaine County Historical Museum.)

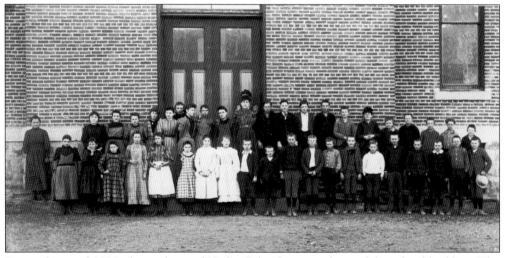

Pictured around 1900, the students of Hailey School pose in front of the school building. The new school signaled improved educational opportunity in Hailey. The *Wood River Times* of July 14, 1887, reported three of the four teachers hired for the fall term had college training. Teacher-principal E.A. Milner had earned bachelor of science and master of arts degrees; Mary Burke had attended the College of Notre Dame in Indiana; and Amy Boggs held a bachelor of arts degree from Cornell College in Iowa. The curriculum was expanded to include a kindergarten and a high school course "to prepare young men and women to enter College or University."

A fourth- or fifth-grade class poses in boys-only and girls-only groups in front of the Hailey School in the 1930s. The large, double-door front entry opened into a sizeable alcove with a hardwood floor and a rail around the wall with pegs for hanging coats. Skis were stacked along the wall and boots left below the coats. Across from the main entry, an elegant wooden staircase with heavy banister led up two flights to the classrooms on the next floor.

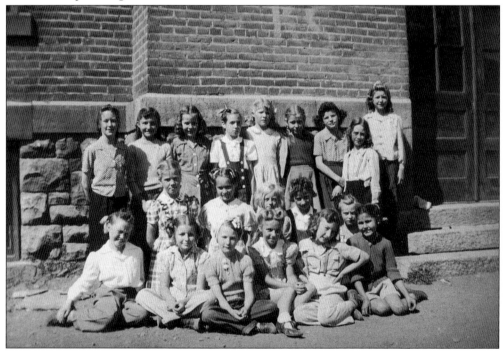

Around the 1930s, football players pose at the Hailey High School football field south of the school building where the Hailey Elementary School playground is presently located. In the photograph above, the varsity team displays their game faces in their game uniforms. Quigley Canyon and the Grange Hall are visible in the background. In the photograph below, younger boys, probably the junior varsity or sophomore squad, display their slightly less fancy uniforms. The leather helmets and lack of face protection made the game rougher in those early days. Photographer Mallory's shadow is also visible in the photograph below.

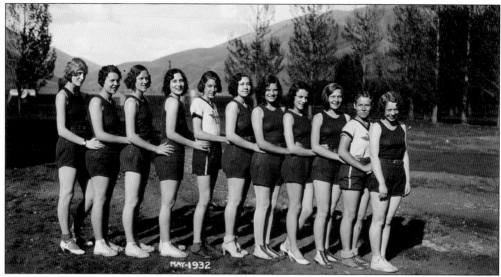

A girls' physical education class poses in stair-step formation at Hailey High School, located east of Elm Street where Hailey Elementary School is today, in the spring of 1932. The second girl from the left is Wilma Horne (Billie Horne Buehler), a lifelong Wood River Valley resident and sister of Roberta McKercher. Quigley Canyon is visible in the background. The photograph below shows the Hailey High School graduating class of 1932 posing on the front steps of the school. Those identified on first row include Bill Brooks (second from left), Maxine Walker (fourth from left), and Frank Parke (fifth from left). Wilma Horne (Billie Buhler) is shown second row on the right. Others shown in the photograph are, in no particular order, Gertrude Cox, Ival Deckard, Walter Galliher, Alberta Gray, Wilma Gray, Mildred Kelley, Wentworth Lambert, Roderick McKay, Murrel Shanafelt, Eltinge Read, and Harvey Young.

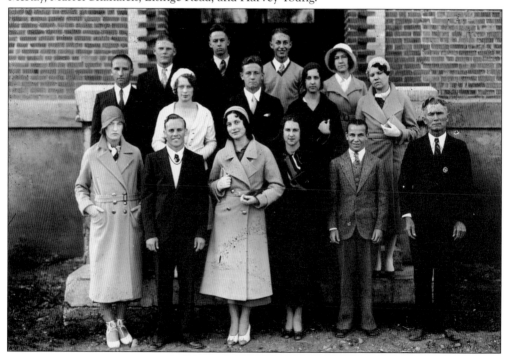

Eight

COMING OF SUN VALLEY

The coming of Sun Valley was an unexpected event with dramatic consequences for the town of Hailey. The inspiration of Averell Harriman, chairman of the Union Pacific Railroad, the resort was intended to provide the ambiance of a world-class European ski resort in the wilds of south central Idaho. The building of the resort provided employment opportunities for a community that was suffering the effects of the decline of the sheep industry in the United States as well as the Great Depression. In March 1936, the *Wood River Times* reported that Charles Proctor, a ski expert from Massachusetts, was recruiting boys from Hailey High School to "train for guides for skiing parties and other winter activities." Following the ground breaking in May, hundreds of local workers were engaged in construction and preparations for the opening of the resort that was completed in just seven months at a cost of $1.5 million. Public relations whiz Steve Hannagan, who had transformed a sand dune into Miami Beach, was hired to handle the resort's marketing. He named the lodge and its facilities Sun Valley and made opening night (December 21, 1936) a gala event attended by movie stars, such as Errol Flynn and Clarke Gable. The opening of the resort also served to introduce a wider segment of the United States and international populations to the beauty and majesty of the Wood River Valley and Sawtooth regions. These events forever altered the fortunes of the town.

Martyn Mallory was hired by the Union Pacific Company to record the construction of the lodge, which began in May 1936. The photograph above shows the lodge in an early stage of construction with Ketchum visible in the background. The photograph below shows another view of the early construction, taken in June or July 1936. By early June, the *Wood River Times* reported that 50,000 board feet of lumber had been supplied by local sawmills with the anticipation of 10 times that amount needed for final completion of the project. Large piles of lumber are visible in the foreground of the photograph; the lumber also provided the forms for the poured concrete walls of the lodge.

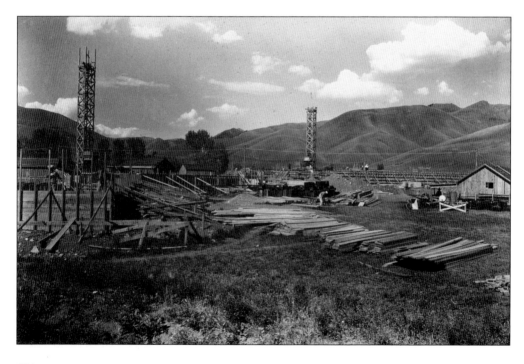

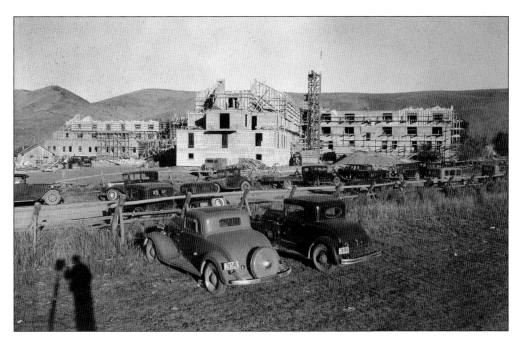

The fourth story of the lodge is under construction in the photograph above. By August, 200 workers were employed with a weekly payroll of $10,000. The workers' income provided a much-needed infusion of cash into the local economies of the Wood River Valley communities. In the photograph below, Sun Valley Lodge nears completion with the roof being installed in October. Parts of Dollar and Bald Mountains are visible in the background.

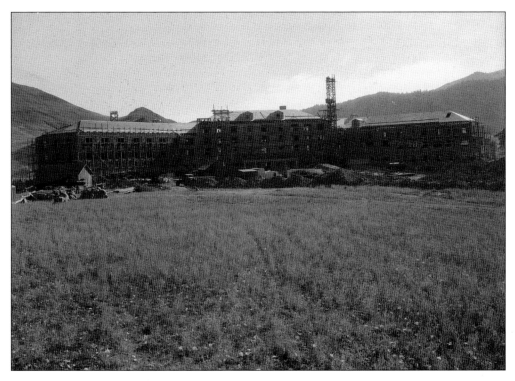

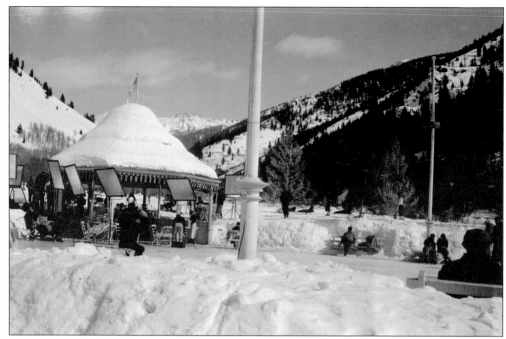

I Met Him in Paris was the first film to take advantage of Sun Valley's location and the amenities it offered. Paramount leased the land from silver prospector Gus Anderson for $500 and built a movie set complete with a Swiss-like lodge (below) that the Andersons moved into after filming was completed. The crew totaled 250. The interest in the area began around December 10, 1936, according to the *Hailey Times*, which reported a party of seven from Paramount was registered at the Bald Mountain Hot Springs and were discussing the possibilities of making a film starring Claudette Colbert. The announcement was made a week later, and most of the film's cast and crew arrived in mid-January. The *Times* further reported that by February 4, 1937, "about 90 per cent of the filming for the picture will be done here," continuing that the company consisted of nearly 300 people, and the cost of the picture well over $500,000.

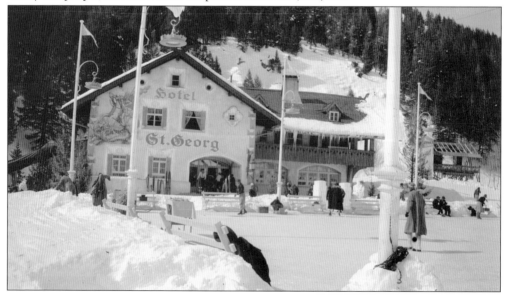

BIBLIOGRAPHY

Buckendorf, Madeline. *Historic Context Statement, Early Settlement and Housing Patterns in Hailey, Blaine County, Idaho, 1880s–1890s*. Unpublished manuscript. Hailey City Hall, 2010.

Historic Old Hailey—A Nineteenth Century Town. Walking Tour Brochure. Hailey, ID: Blaine County Historical Museum, 2007.

Holland, Wendolyn S. *Sun Valley An Extraordinary History*. Ketchum, ID: Idaho Press, 1998.

McLeod, Geo. A. *History of Alturas and Blaine Counties, Idaho*. 3rd ed. Hailey, ID: *Hailey Times*, 1950.

Mitchell, Victoria E. *History of the Triumph, Independence, and North Star Mines, Blaine County, Idaho*. Idaho Geological Survey staff report. Moscow, ID: University of Idaho, 1997.

"Sheep Farming—A Question of Survival," The *Economist*, February 5, 1998, accessed February 14, 2012, www.economist.com/node/112451.

Spence, Clark C. *For Wood River or Bust*. Moscow, ID: University of Idaho Press, 1999.

Strahorn, Carrie A. *Fifteen Thousand Miles by Stage*. New York: Knickerbocker Press, 1911.

TAG Historical Research & Consulting. *Narrative History of Hailey's Historic Crossroads*. Unpublished manuscript. Hailey City Hall, 2011.

www.summitpost.org/

www.sunvalley.com

www.trailingofthesheep.org/

DISCOVER THOUSANDS OF LOCAL HISTORY BOOKS FEATURING MILLIONS OF VINTAGE IMAGES

Arcadia Publishing, the leading local history publisher in the United States, is committed to making history accessible and meaningful through publishing books that celebrate and preserve the heritage of America's people and places.

Find more books like this at
www.arcadiapublishing.com

Search for your hometown history, your old stomping grounds, and even your favorite sports team.